How to Make Money as an Artist

How to Make Money as an Artist

The 7 Winning Strategies of Successful Fine Artists

Sean Moore

CHICAGO
REVIEW
PRESS

Library of Congress Cataloging-in-Publication Data
Moore, Sean.
 How to make money as an artist : the 7 winning strategies of
successful fine artists / Sean Moore.
 p. cm.
 Includes index.
 ISBN 1-55652-413-7
 1. Art—United States—Vocational guidance. 2. Art—United
States—Marketing. 3. Art—Economic aspects—United States.
I. Title.
N6505.M585 2000
706'.8'8—dc21

 00-038406

Cover and interior design by: Rattray Design

The author and the publisher disclaim all liability for use of the
information contained in this book.

Published by Chicago Review Press, Incorporated
814 North Franklin Street
Chicago, Illinois 60610
ISBN 1-55652-413-7
Printed in the United States of America
5 4 3 2 1

CONTENTS

3

JOIN ART CLUBS, ASSOCIATIONS, AND ORGANIZATIONS 49

4

GET INTO JURIED SHOWS 55

5

6

7

MAKING PRINTS AND OTHER WAYS TO LEVERAGE YOUR WORK 105

INTRODUCTION

How to Make Money as an Artist is a handy, easy-to-use guidebook for the working fine artist. Its compact size makes it easy to carry with you and refer to when needed.

Most reference works for artists are dense encyclopedia-size volumes put together by committees and editorial staffs trying to impress users by sheer size. Much of the information in these books is designed to be useful to the commercial artist. Most of the resource listings in them are irrelevant to you, the individual fine artist. To create *How to Make Money as an Artist*, I read these volumes; sifted through information offered in other media; interviewed authorities in the art world, marketing communications experts, gallery owners, art collectors, directors and members of art organizations, artist representatives, show jurors, museum professionals, public arts administrators, art critics, successful artists, advertising agency executives and creatives, media buyers and sellers, and printers and public relations specialists. This book is the distillation of that research combined with 30 years of experience as a working artist, teacher, and marketing communications

professional. The result is this simple and straightforward resource guide, from one artist to another.

How Do Artists Make Money?

What are the professional secrets of successful artists? How do they get in shows? How do they sell? How does their work get reproduced and sold as prints? How do they get on the Internet? How do they get publicity in the media? Their work isn't always better than yours. Talent doesn't have everything to do with it. Knowing just *what* to do, *how* to do it, *when* to do it, and then *doing it* are the keys.

Too many artists have been influenced by the cultural myth that artists trade security and amenities for freedom and aren't supposed to be successful in any material sense. This is the myth of the bohemian. It is a myth perpetuated by those who envy the mysterious talent that demands so much freedom and who take comfort in their more practical lifestyle.

The popular romantic notion of the artist as a lonely, offbeat character in a garret or out in the middle of nowhere is a cultural cliché that started in the late 19th century because of such figures as Van Gogh and Gauguin. It wasn't always like that. You can bet Michelangelo, Titian, Tintoretto, and Raphael didn't pick up a chisel or a paintbrush unless the florins were on the table. They sought out clients who were willing to pay, and clients pursued them with commissions. Today, Andrew Wyeth, who rarely leaves his farmhouse in Chadds Ford, Pennsylvania, fits that romantic notion. Yet he's one of the most highly paid artists in the world.

Success in art isn't an all-or-nothing proposition as the popular culture leads us to believe. Just because most people know only the amateur next door and the superstars in the media, they think there is no in-between. The myth is that success in art is a roll of the dice or you get "discovered" after you're dead. (You cannot be discovered after you are dead. Your artwork can be, but that would be of no benefit to you.) The sensible thing to do right now is to move yourself up into the broad middle ground where

most professional artists live, work, and make money. Once there, you have positioned yourself to move higher. Following the strategies in this book will help you advance your career.

Think of these strategies as a single art project you're creating simultaneously with your other artwork. By thinking of it this way, you'll be free to continue other art projects and succeed during busy periods when you exhibit in a show, win an award, get a commission, or make a sale to a collector. By following the strategies detailed here, you'll expand your career. This is the art they didn't teach you in school. Now let's begin.

How to Make Money as an Artist

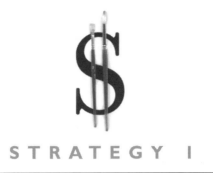

Create a Winning Marketing Package

AN IMPRESSIVE MARKETING package is the most powerful weapon in your promotional arsenal. If you follow these step-by-step directions, you'll end up creating a ready-made, off-the-shelf missile to fire at galleries, collectors, art representatives, advertising and public relations outlets, and the media. It will be perfect for grant proposals and scholarship/fellowship applications, too.

A winning marketing package contains a number of items. These include

- A biography

- A resume

- Slides and photographs

- Business cards and stationery

- News releases and press clippings

- A portfolio

Additional items include a slide list to go with the slides, and two smaller versions of the portfolio—one for sending out and a pocket-sized version to carry with you at all times.

Your Biography

Your biography should be no longer than one page and 200–300 words total. A short biography will contain much of the same information as your resume, yet it will appeal to those who like to acquire information in prose form. The biography that you add to your marketing package should not be a compressed history of your life. It should include only the information that relates to your evolution as an artist. If you don't have a biography, here are some simple steps to building one.

1. Make notes. Start by jotting down notes quickly and spontaneously. These are words and phrases you come up with by using free association. These notes should include everything you can think of that has anything to do with your experience as an artist and might include lessons, schools, teachers, shows, sales, and prizes. Don't hold back or edit this information at this stage.

2. Outline. Arrange these in some logical order and make a simple list of all these notes. Then edit out the ones that don't seem worthwhile.

3. Write prose. Flesh out each note to form a complete sentence, then organize these sentences into short paragraphs. This should read like a mini-story with a beginning and a middle, and should culminate in your present level of development.

The biography should include relevant education, workshops, courses, and jobs in art. It may include prominent exhibitions, collections, art organizations, and academic institutions from your past or your present. It might include known, distinguished teachers who may have influenced your work. For example, Jackson

Pollock studied with Thomas Hart Benton. While it's hard to see much of Benton's influence in Pollock's painting, Pollock was able to trade on Benton's reputation before he established his own. Your biography needs to include any awards you've received, including scholarships, grants, and show prizes. Here's an illustration from a fictional artist who has pretty good credits.

> My new series of blue and green abstract acrylics are inspired by views of the Connecticut coast and sailing on Long Island Sound. I was born in Woodstock, Connecticut, and attended Yale University School of Art and Architecture on an athletic scholarship. While at Yale, I studied design under Josef Albers and won first prize in the Greenwich Arts Festival.

4. Write an artist's statement. Your biography must include a statement of purpose called an artist's statement.

An artist's statement is a brief description of your aesthetic; that is, why you do your art, why you do it in a certain manner, and what it means. An artist's statement is often needed if you want to make money as an artist. For example, it is regularly used by gallery staff to tell customers something about the "why" of your work.

An artist's statement can be difficult for many artists who don't consciously think about purpose. "I just like to draw" doesn't pass for an artist's statement. You need to put clear thinking into this. Your purpose doesn't have to be some grand altruistic humanitarian aspiration, nor does it have to be a deep tortuous psychological excavation. If you think only about formal and technical matters when you work, then say so. They are perfectly valid artistic concerns and may distinguish you more clearly from others' vagaries. Keep in mind that Impressionism, Cubism, Op Art (optical art), and Photo Realism are about no more than such visual artistic matters. If your artistic output is inspired by a save-the-world scheme (the plight of the poor, the national parks, flying saucers, worship of God), the connection should show clearly, so you can be modest about it in your statement.

Whether you're a mechanic or a mystic, put your artist's statement in simple straightforward language. The gallery sales people and the media tend to use sound bites from it. If it's obtuse, quotes out of context will sound foolish or pretentious. Try something like this:

> While Albers's Bauhaus-influenced "concentric squares" paintings impressed me at the time, I later found the sterility and lack of feeling in his geometric compositions not suited to my personality and love of brushwork. I feel the same way about his lack of external reference—I want my paintings to be about something. Much as Neil Welliver, influenced by Albers's limited palette and flat areas of color, adapted them to his dense paintings of the Maine woods, I've taken the colors, loosened up the geometry, and added brush strokes. In that aspect my paintings are related to Richard Diebenkorn's California coastal scenes. Though my sketches and drawings of the Connecticut coast are representational, my broadly painted acrylics are intended to evoke rather than portray.

A little highbrow and inappropriate, but you get the idea. The descriptions of the works in the above example give the reader a rough idea of what the works look like even though the paintings are not being seen. The compare-and-contrast technique with three other artists, in turn, sets up a "triangulation" that helps zero in on what your work is like. Note that the reference to Welliver and Diebenkorn, two highly successful contemporary American artists whose works hang in museums, is a valid use of borrowed interest that gives you a leg up by association.

Relevant memberships may be included in the biography as a way to bring in some nonartistic purposes if you have them.

> A member of the Cousteau Society and the Sierra Club, I am also active in the National Trust, which works to preserve the natural beauty of our coastlines.

This is enough. Your marketing package isn't the place for a lecture. You're selling your artwork and, to some extent, you as an artist.

5. The hook. Finally, your biography should have a *hook*, also called a *handle*. This is something unusual about your background, your art, or yourself that will grab attention and make people remember you.

You might not think there's anything unusual about yourself, but there always is something. Enlist the help of your friends by asking them what they think is unusual about you and/or distinctive about your artwork. It's often something so obvious and taken for granted that you don't notice it. For example, Andy Warhol once worked a boring job as a commercial artist for a shoe company. His graphic design and illustration background showed clearly in the images and techniques of his mature style.

If you're a housewife and mother who fits her sculpting in between the children's school and managing the home, you might think it sounds ordinary, but there's a hook that will make a lot of people say, "Wow, how does she do it?" Here are some things to think about when creating a well-developed biography:

- Maybe you studied abroad or you were born abroad. (My main painting professor in Connecticut, John Gregoropoulos, was born in Athens, Greece. His large white abstracts with pastel silhouettes and gold-leaf suns reflect this.)

- Maybe your artwork is done in a style from the past or even from the future.

- Maybe you're very young or very old.

- You're an expert on some arcane subject.

- You have another present occupation such as a yachtsman, mountain climber, or musician. (A member of my

art club is a psychiatrist who produces artwork obsessively and shows in art exhibitions compulsively.)

Your Resume

A resume is a work-related biography in outline form that you use when looking for a job, but an art resume is different. Your artist's resume should include only items that relate to your history as an artist—the idea is to impress art world professionals and potential buyers at a glance.

Your resume should be no longer than one or two pages. If you don't think you have enough to fill a resume, you already have the bare bones started when you worked on your biography. You'll be able to fill it out nicely as you move through the following strategies in this book.

Your resume may include most of the following headings:

- Awards and Honors

- Exhibitions

- Collections

- Articles and Reviews

- Publications

- Lectures and Appearances

- Commissions

- Jobs in the Art Field

- Education

- Memberships

Begin by including your name in boldface type at the top. Follow this with your address, telephone number (including area code), fax number, and e-mail address. Immediately under this, include your place of birth (this can be a conversation piece) and your date of birth (optional).

List the most impressive or most recognizable credits first so a hurried reader who's just skimming the headings down the page will see them. The only exception to this rule is under "Jobs in the Art Field" and "Education." Here, place the most recent items first as you would in an employment resume. Lead with your strength.

Awards and Honors. It's exasperating how many artists bury this good stuff at the very end. If you've won some prizes they should be up front to make a strong impression that says, "This artist is a winner."

Exhibitions. Make a straightforward laundry list of all the art exhibitions where your work has been shown. It doesn't matter whether they were juried, by invitation, or something that Bonzo the chimp could get in.

If your credits are longer than an epic poem, or if you don't have many credits under your belt and some are obviously weak, sharpen the list and use the heading "Selected Group Exhibitions."

If you've had a one-man or one-woman show it will look good even if the venue was small. It shows you have a body of work large enough to fill some gallery. In this case, I prefer the heading "Solo Exhibitions." (I like this instead of "One-Man Shows" because it avoids the politically correct gender hassles, covers everybody, and is shorter.) Here's an example:

Solo Exhibitions
Bootstrap Gallery, Cambridge, MA, 1995
Woodstock Public Library, Woodstock, CT, 1992
Yale University School of Art & Architecture, 1990

Selected Group Exhibitions
New Women at Yale, Connecticut College, New London, CT
Ten New Talents, Avant Garde Gallery, New Haven, CT
Visions of the Sea, Rusty Scupper Gallery, Mystic, CT
Fall Show, The Artist's Co-op, Boston, MA
Fort Point Channel Open House, Boston, MA
About Cambridge, The Cambridge Art Association, Cambridge, MA
Christmas in Connecticut, Woodstock Public Library, Woodstock, CT

Include the dates of the shows at the end of each line, or even at the beginning if you had one recently and there's a nice chronological flow after that. If these dates are old or you can't remember a date for each exhibition, leave the dates out.

Collections. This should be another linear list. Write down all the private individuals, organizations, and institutions owning one or more pieces of your artwork. It doesn't matter whether they bought the art from you or from someone else, whether you gave it to them as a gift, or whether they received it as stolen property. If they acquired your work and still own it, they go on a list of collections of which you are a part. You can edit this list later if appropriate. (Note: Avoid too many surnames on your roll that are the same as your own. You don't want it to look like only members of your family can stomach your artwork.) Here's an example:

Collections
Biotron Corporation, Inc., Woburn, MA
Bay Bank, Boston, MA
Marriot Hotel, Newton, MA
The Lexington Press, Lexington, MA
Wadsworth Athenaeum, Hartford, CT
Yale University, New Haven, CT
Town Hall, Woodstock, CT
The Pomfret School, Pomfret, CT
Mr. & Mrs. Local Art Collectors, Woodstock, CT
Dr. & Mrs. General Practitioner, Woodstock, CT
Mr. & Mrs. Artist's Rich Uncle and Aunt

A number of consultants believe this list should include only museums, corporations, institutions, organizations, and big-name individuals. I think if you're going to be selling to ordinary people some of the time, it can be reassuring to them to see other such names among your collectors—though the big names give them buying confidence by showing that people in the know bought before they did.

Articles and Reviews. This is a list of publications, including catalogs, in which your work is mentioned or reviewed. Include the title of the publication, title of the article, the author's name, and date. Photocopies of actual clippings can be included later in your final marketing package.

Publications. This includes all books, articles, or reviews you've written. For each listing, include the title, publisher, location, and date. If you wrote and published something like *Megatrends*, or you're the regular art critic for a well-known newspaper or magazine, you might want to place these closer to the top of your resume.

Lectures and Appearances. If you've given lectures aside from those in a regular teaching position, list these according to the name of the organization or other location, what they were about, where, and when. These items show you're serious about your art and that other people think so, too. If you've been on television, radio, or in a video, list these here and include where, when, and what it was about. These show you're promotionally minded.

Commissions. These are contract jobs where you've been commissioned (hired) to create some work of art, such as a public sculpture for the park or mural for a corporate cafeteria. Here you should name each project, medium, client, place, and date. You may include volunteer projects under the heading, too. For example, maybe you helped make one of those quilts that stretch across the country. If so, this is worth mentioning. This will be especially important to mention if your volunteerism relates to what you're doing now—if, for example, your artwork is now large in size or you're a textile artist.

Jobs in the Art Field. This should include only jobs that relate to your development as an artist, from summer jobs and Christmas help to fully-realized professions. Teaching art is probably the best job to list. But if you've worked in the art department of an advertising agency, a design studio, or an in-house graphics department, that's OK. The fine-arts crowd tends to look down their noses at these commercial debasements of art, but if you can be convincing about how they contributed to your particular

artistic development, like Warhol, you may include them. James Rosenquist, painter of mural-sized Pop Art works, was a billboard painter.

Education. Recent college graduates put their degrees right up top. It's a dead giveaway they don't have much else going on, and graduating college is the biggest thing they've done. Putting it later highlights that you've had achievements in the art world since graduation. And if you don't have a lot of formal education, it's best buried near the end, too. Gallery owners and other art professionals are often well educated and are more comfortable dealing with people like themselves. And whatever lip service they might pay to "natural talent" and "primitives," they really believe that more sophisticated people create better art.

Any degrees are good, but the BFA is the one gallery owners and collectors long to see. An MFA is even better. A degree in art shows you're serious about it and have been all along. (They like consistency.) If you don't have a degree in art, that's OK. Many successful artists, like Winslow Homer, were mostly self-taught. Mention any college or high school courses of note here, also.

If you don't have a degree in art and, for that matter, even if you do and have studied further, list courses, workshops, art colonies, seminars, tutoring, lessons, or independent study work as well. Also, name any instructors of note. Put a positive spin on these activities. If all you can think of is arts and crafts at summer camp, maybe it would be fair to describe it as a workshop or even tutoring. Keep in mind that everything in your resume must be true. Describe briefly what you did in these courses. Make it sound rigorous, serious, and special. (Notice how many of these items relate to the biography section, and vice versa. This is the way it should be. When you get one perfected, use it to improve the other.)

Memberships. Include all the arts organizations to which you belong. Be sure to include any volunteer activities or positions held. (See Strategy 3 for more details.)

If you are young and in the early stages of your career, there just might not be enough meat there for either the biography or resume to fill a whole page. The same might be true if you're a late

starter, but don't worry—Van Gogh didn't get going until he was 27, and Gauguin was 35. Then there's Grandma Moses.

So at this point, if you're so short on documented artistic accomplishments that both your resume and your biography are still weak, don't panic yet. As you start taking the steps in the rest of this book you'll gain plenty of strength. In the meantime try adding white space between headings. If instead of looking "clean" and "uncluttered" it looks deprived and barren, you can combine the biography and resume into one document. Start with the prose-biography part, then introduce some resume-style listings. Do this artfully and you can make a tight, likable read.

Then, when you and your coaching staff are convinced you've presented all the best credits you have in the best possible light, proofread for grammar, spelling, and punctuation.

Now it's time to determine the typeface and layout. If you can take your copy to a good resume consultant, it will be well worth the extra $35 to $50.

Layout

Get a book of resumes or use someone else's great-looking resume as a model for your layout. Don't experiment with anything tricky to make yours look different. If you make it difficult for readers to figure it out, fewer will read it. Use the simplest, most straightforward layout that suits your material. In a resume, it is the content, not the style, you want to get across. Here are some design tips.

Use serif type. This is the most important advice you will ever get about typography. For the record, serif type is the kind with the little doohickies on the tops and bottoms of the letters. *Sans* (meaning "without" in French) serif is without them. Though there are thousands of typefaces, all type falls into one of these two categories—they either have serifs or they don't.

<div align="center">This is serif type.</div>

<div align="center">**This is sans serif.**</div>

Serifs are vestigial to script and help the reader's eye flow across the words. It is not an accident that virtually all newspapers,

books, and magazines are set in serif type. It's what people are most accustomed to reading and read most easily. If you throw something different at your resume reader, she will have to make an adjustment. Why make it harder to decipher your message? Market research shows that advertisements and other marketing-communications pieces are read more when they are in serif type. Art directors and graphic designers love sans serif type. They feel it looks cleaner, more designlike, more modern. It does. It works fine for logos and short bold headlines, but it's not good for reading copy.

LOGO DESIGN

BIG SALE BUY NOW

Don't set your resume on a typewriter. It will look amateurish and obsolete. Use a computer or have it typeset by a professional.

Set the lines ragged right, not justified. This will give a more even "color" to your type blocks.

Justifying (flush right) forces some lines to stretch and others to squeeze, like the newspaper, in order to meet the right margin.

Some artists like to center their copy blocks.

This may look pretty as poetry
but it's harder for the readers
to find their way back to the
beginning of the next line.

Avoid using all uppercase type. IT LOOKS LIKE A DECLA-RATION OF WAR AND IS HARDER TO READ. Stick with the normal upper- and lowercase type used in regular sentence structure in books, magazines, and newspapers. If you need display, go bigger or punch up to bold.

Bold headlines can make it easier for the reader to locate topic headings.

Smaller bold subheads and indentations can help the reader prioritize clumps of information.

By this point you should have written your biography and resume, including awards, exhibitions, collections, and more, and had your resume typeset. If it's been reset from your original copy, it should be proofread for spelling and punctuation errors. After you've proofread the copy, ask someone else to do it, too. A fresh pair of eyes might find other things you've missed.

Next, look over the pages as a whole. Look over your resume a couple of times, each time focusing on just one of the following elements:

- Are the indents in accord?

- Is the punctuation or lack of it in agreement?

- Have you used boldface consistently by category? Italic type (if used)?

- Is the overall layout pleasing to the eye?

Then, proofread again for spelling and punctuation.

Use the highest quality paper you can. This is often the first impression someone has of you and your artwork. It could be your only shot. Make it your best. Laid stock (grainy paper, higher quality than photocopy paper) is a good choice. Choose an off tone—stark white looks like a business form. Artists are supposed to be interesting, not boring.

Slides and Photographs

Your marketing package needs to include images of your work so your audience can see it. All the description in the world of the art or the artist can't replace seeing the real thing.

You have a number of format choices here, including slides, black-and-white prints, color prints, and/or digital prints. You also have choices on how to acquire these images for your marketing package. You can hire a professional photographer, hire a student, or do it yourself—your choice will largely depend on your budget.

Hiring a Professional Photographer or Art Student

The best way to get slides and photographs of your artwork is to hire a professional photographer experienced in shooting artwork. Slides are often the first representation of your artwork seen by galleries, jurors, buyers, artists' representatives, and grant committees. If they don't look great, that's all they'll ever see.

If you cannot afford to hire a professional photographer, the next best thing is to go to the photography department of a local art school. Ask in the office for a referral or post a help-wanted ad on the bulletin board. You might already find ads from students looking for this type of work. You want a student who isn't charging a lot, seems conscientious, and has access to the school's studio and equipment.

Here are some tips to get what you want when contracting with someone else to shoot your artwork.

- Whether using a professional or a student, check the person's references, especially other artists whose work he's shot.

- Ask to see examples of the type of work you want to contract.

- Make sure that the shoot is guaranteed.

- Make a contract that specifies you own the copyright of the image of your artwork and that the photographer may not use copies of your work without permission. (A photographer may want to use the images of you and your artwork for promotional samples and this is OK.)

The most efficient and, in the long run, least expensive approach is to get all the different types of shooting done at the same time. You'll have to round up all your artwork only once. You can avoid duplicating set-up charges this way. The photographer has only to change cameras on the tripod to progress from one kind of shot to the next.

Bring your artwork to the photography studio if you can. There, the photographer is properly set up and has his equipment, such as lighting, seamless backgrounds, different-size cameras, and more. If unexpected problems arise, the photographer won't have to interrupt the shoot to go and get what he needs.

If you can't transport your work or it's inconvenient, most photographers are willing to bring enough equipment to your studio or the site to do the job. Many will pick up and deliver.

Prices will vary not only by who does the photographing of your work, but by the type and number of images you need. Here are some things to keep in mind when deciding what you need.

Prices vary, so describe the job to them, including how many pieces of artwork, size of each, what medium, how many copies of each slide you'll need, and what other kinds of pictures you'll need. They will give you a close estimate. Recent prices range from a low of $25 per hour to a high of $65 plus $1.25 per slide or a flat $69 per 36-exposure roll. These prices are for 35mm film.

Doing It Yourself

You may choose to photograph your own work. However, I discourage you from making this choice unless you are highly skilled and experienced.

Here are some tips if you must do the photographing yourself.

- Get some professional advice.

- Shooting outdoors on a bright but overcast day is better than indoors without special lights.

- A tripod is a must.

- Use the book *Photographing Your Artwork* or other

resources listed in the back of this book for essential information on this process.

Format

Once you've selected a photographer to shoot your work, you must decide on the format or output that you want.

35mm Slides

In general, 35mm slides are still standard, but you might want large-format transparencies, usually 4″ × 5″, which are great for fine-art reproduction. The traditional (four-color offset lithography) print houses like to start with 4″ × 5″ transparencies, which are also optimal for newer printing techniques like Giclee prints and Reprochromes.

Black-and-White Prints

You'll need black-and-white prints of your artwork to include in news releases (see Strategy 5) that you send to newspapers and magazines. Have the photographer pose you in some of the pictures with your artwork. Pictures of you and your work together are excellent promotional pieces. People like to have a sense of who does the art, and the connection of art and artist helps them remember both better.

Newspapers like pictures with people in them because they have more interest. To make them worthy of interest, you can have yourself posed doing something, such as wielding a big brush, hammering a piece into a sculpture, or creating a mood. Look at pictures of Salvador Dali or Pablo Picasso posing with their work—they were both masters at projecting their personae. If you feel action pictures look contrived or show-offish, just pose in a straightforward manner. People will still make a connection between the art and an actual human being.

Take your photographer's advice about which shots to use. Not only are photographers artists, they're commercial artists who are used to picking the best picture out of many. Larger sizes, such as 5″ × 7″ or 8″ × 10″, are good for public relations (PR) purposes, but 4″ × 6″ is OK, too.

Color Prints

You'll need color prints of your artwork for your portfolio, and the rule is, the bigger the better, up to the dimensions of your portfolio. You will also need 4″ × 6″, 5″ × 7″, or 8″ × 10″ prints for creating mini- and midi-portfolios. These are your off-the-shelf presentation portfolios that feature your wares and are sent to dealers, collectors, gallery owners, reviewers, and others. See a description of a mini-portfolio on page 26.

Digital Photographs

Digital photographs are taken with a special camera that looks and operates like a regular camera but involves no film or developing. These cameras interface with your computer. The images can be viewed on the computer's monitor and can be altered and combined. Prints are made with a high-resolution color printer.

Among their many advantages, digital images can be combined with type so you, or someone who knows how, can design brochures, flyers, mailers, business cards, and other marketing materials right on your computer screen. You can also produce limited-edition prints, up to your printer's maximum size, to frame and sell.

After the Slides Are Done

When the slides are done there are a few things you have to do before they are ready to use.

Pick the best slide of each piece of artwork (keeping in mind the photographer's recommendations). Mark it "original." Save other good ones, just in case.

If a professional shot your artwork, you shouldn't have any unsightly background showing at the edges of the slide. Do-it-yourselfers often have wallpaper or bushes showing at the edges. This should be cropped. (Get mylar tape for this purpose at a photography store. If you can get the slide out of the frame, you'll do a neater job of aligning the tape to the edges of the wanted image.)

Have duplicates made of the selected slides. Remember, film is cheaper than duplicates, so go for good originals. Mail order is

the cheapest way to duplicate slides. (See the Marketing Resources section for suggested companies.)

Each slide must be labeled with specific information. Different shows, registries, art associations, and grant committees have different ways they like the information presented on the slide. These quirks are supposed to be described in the prospectus. Check before sending. Most need to have your name, address, telephone number, title of the artwork, medium, dimensions (always height first in this form: 24 × 36″), date completed, and an arrow on the right, showing correct side up. It's not easy to get all this information on such small spaces. You can use abbreviations such as "wc" for watercolor, "o/c" for oil on canvas, and "ac/c" for acrylic on canvas. Placing your personal information on the back leaves more room for your name and picture information on the front. Some duplicating services can print all this information right on the slide frame. This may cost extra. Or you can get printed, stick-on slide labels that look neat and professional. (See the Marketing Resources section for company names.)

Slip the selected slides into the fitted pockets of a slide sleeve. You will find these handy holders at any camera shop. You can trim off some of the pockets to fit just the number of slides you want to carry. Use the high-density polyethylene instead of PVC—it's a better quality material.

Create a slide list. Various venues will want a slide list—that is, information about the slides on a separate sheet of paper. This should be done in the following format:

Using an 8¹/₂″ × 11″ sheet of paper, type your letterhead at the top with the words "Slide Sheet" underneath. Then make a list of each slide that's included, creating four columns of information. The first column is for the title of the work, the second column is for the medium, third is for the dimensions of the piece, and fourth is for the price. Such a sheet helps viewers because when your slides are locked into the carousel of the projector, the information printed on them cannot be read. Creating this kind of sheet also helps you because you can change your prices when you want by changing this sheet (which you should save on your computer, so you can edit it without too much work).

Business Cards and Stationery

Business cards and stationery are essential to creating a professional image. With these, you will look organized and will leave people with a favorable impression.

Business Cards

Having a business card is an obvious, but very important, everyday method to get your name, your artwork, and your message out. It's also an easy way for people to access your name at some

later date. Amazingly enough, though, most artists don't use them. It's surprising but true that many fine artists are inept at designing anything with type and small graphic elements, especially for themselves. Maybe you think business cards are too businesslike. Try thinking of them as calling cards or, with your artwork on them, as art cards—little gifts you give away. Business cards are too important to your success to avoid. Imagine if you, with your business cards, and another artist, without business cards, meet a dealer or collector at the same time. Which one of you is more likely to be contacted later? It won't matter who's the better artist.

In the late fall I met an art dealer at a show in which I exhibited. We chatted for only a minute and I gave her my card, a big card with a color reproduction of a painting I had in that show. (I deliberately carried a show-specific card because it would make a stronger connection.) She called after the holidays to ask if I would be interested in a project on which she was working. She had a big corporate account that commissioned her to acquire artwork to fill the walls and spaces in a downtown office building, and she thought my style would be just the ticket for them. I was interested. First, I sent her my marketing package (which is just like the one you're building for yourself right now) so she could show it to the corporate client. Then, I suggested she visit a gallery where my work was hanging before we arranged a meeting. A week later we met, fell in love (in a business sense), and today we're making beautiful sales together. The moral of this story: You need business cards!

There are a number of ways you can get business cards.

1. You can go to a job printer or copy center and pick a card design from their style books. These will cost you about $20 for 1,000, and will make you look like a door-to-door salesman.

2. You can design a card on a computer that has business card software and is connected to a color printer that will print on Avery business-card forms, which will cost about

$10 for 500 cards. This is a good way to make a professional and personalized business card.

3. You can hire a professional graphic designer. This is an excellent but expensive option. Give the designer a copy of a piece of your artwork. After you approve the design, the designer will take the camera-ready art to a commercial printer. You'll get hundreds of four-color cards on a card stock of your choice, and you can get oversized cards if you want to show off your artwork better.

4. You can create your own cards with a photocopier and a few art supplies. This method is highly recommended. First, have some of your artwork reduced by laser scanner or color photocopier to $3^{1}/2''$ or less. Then, set type with the information you want on the back of the card. Paste several on an $8^{1}/2'' \times 11''$ white backing. (Be sure to add in crop marks or corner dots so you'll know where to cut out each card.) Make color photocopies of this sheet onto card stock. Cut out the cards using a T square, triangle, and X-acto knife, or a paper cutter. If you make your oversized cards twice standard size, you can score the middle with an X-acto knife and steel ruler so they'll fold cleanly to standard size. Then they'll fit in with others and more likely be kept.

This method should run you about one dollar per sheet of card stock. If you can fit four on a sheet, your cards will cost only 25 cents each. This is a high per-card price, but for one or two dollars, you have a wallet full of cards with full-color reproductions of your artwork. You can carry a selection of different ones with you, change and update them as often as you please, and offer people a choice. They love it.

Stationery

A fine artist needs stationery for many reasons. It's vital to maintain correspondence with art representatives, gallery owners,

agents, and others. It is vital to maintain correspondence with the marketplace. As a businessperson, you also need invoices, news releases, thank you notes, and written introductions. In other words, you need stationery.

The same options for creating your own business cards apply here, too. That is, you can go to a copy center and buy standard designs, hire a graphic designer, or use your own computer. If you have a computer in your studio or home, you can design your stationery, set up the margins for the text that you'll write onto each piece, store it, and print it out when needed.

A color printer can put scanned reproductions of your artwork right on your stationery. I recommend this addition to your stationery. We're in a visual medium. A picture really is worth more than all the words of correspondence.

Using a color photocopying machine isn't economical here because you won't be able to save by ganging up your images. Each sheet will cost you at least one dollar, so this method is not recommended. Of course, if you keep all your stationery to black and white, you can print your pieces on a copier for pennies. If you choose to hire a copy center, select a high-quality paper for each piece of stationery you need copied. However, compact photocopiers for home office use are becoming cheaper than computer printers. You'll find so many uses for one, saving you trips to the copy center, that this versatile device could pay for itself in months.

Most likely you can adapt your main stationery sheet to other functions such as a news release, invoice, or receipt. With a computer or copy machine, you can add the necessary elements to your basic letterhead. For example, to make your stationery into a news release form, set the words "News Release" in large type toward the top of the sheet. On the line just underneath, type the words "For immediate release" or an appropriate date when you wish the news to be published or aired.

The following information should be included in the stationery letterhead:

Sean Moore
123 Royal Court
New York, NY 10016
Telephone (212) 555-1234
Fax (212) 555-5678
e-mail　　seanmoore@yahoo.com
News Release
Contact　　Sarah Representative
　　　　　(212) 555-5555

YOUR LETTERHEAD

News Release

Contact:
Phone # *For Immediate Release*

#

The design of your envelopes must be graphically and typographically consistent with your letterhead and business card. A picture on the outside can make a recipient eager to open the mail. A computer, offset printer, or copier can produce envelopes in the same way as your other pieces of stationery. You can add the words "News Release" to your envelope to flag an editor's attention.

News Releases and Press Clippings

If you don't have any old news releases or press clippings included in your marketing package, create them! Write news releases about things you've already done, shows in which your artwork has appeared, prizes you've won, or any interesting thing about you and your art. They will look like releases you used at the time. Date them accordingly. (To learn how to write winning news releases, refer to Strategy 5 under Public Relations.)

Assembling Your Marketing Package

Assemble the slide sleeves, slide sheets (with prices when needed), black-and-white photographs, and color prints, along with your biography, resume, and three sample news releases and copies of press clippings. Then, arrange them artfully and logically in a sturdy business folder that has high pockets on the inside. Buy the folders that have all the outer edges folded inward and glued, for a smooth, solid feel. Good folders are made in heavy coated stock, come in various colors, and measure 9" × 12". The front of one of the pockets will have slots into which you fit the corners of your business card. (If you use an oversized card you can measure and make new slots with a mat knife.)

Any good stationer will stock such folders or can get them for you. Avery (a business forms company) now makes a folder kit with a cover that can be fed through your computer printer. This means that any graphics you have in your files, such as pictures, letter-

head, or other type, can be printed right on the front of the folder for a custom look and perfect match with your other graphics.

Another way to assemble your marketing package is to get the whole thing bound, like a book. Formats you can use include GBC, wire, or perfect-bound with heavy tape available in different colors. The cost for this begins at two or three dollars and goes up from there depending on the cover stock you choose, the number of pages, cuts, and punches. Contact your local copying center for current prices and techniques. A disadvantage to binding is that it inhibits quick-change artistry—it's more difficult to personalize your presentations depending on the potential client— and you have to take your books back to the binder any time you want to add new pages. (Buying your own binding machine would be a substantial investment.)

Either way, folder or booklet, you must select a color that suits your artwork. Black and/or white are strong choices and go with almost everything. These also do not distract from the colors in your work. If your artwork is black and white—etchings and mezzotints only, for example—definitely do not use a color folder. It will make your work look drab by comparison. A shiny black folder could make the blacks in your charcoals or mezzotints look weak. A bright white folder could render your highlights dull and dirty. Try out one folder and build a prototype before you invest in a set.

Once you've selected your folder, customize it by gluing a graphic on the front. A computer can print your image on a mailing label with rounded corners and a sticky back. This label should include a picture of your artwork as well as your name and address. One of the pictures of you with your artwork, and your name printed large, is very effective for instant recognition.

This completed folder that goes inside your main portfolio also becomes your midi portfolio—a 9″ × 12″ off-the-shelf presentation that can be delivered, in a distinctive envelope, to dealers, collectors, reviewers, and others who want to see your wares but don't need a personal interview yet. A well thought out portfolio, however, can get you that interview.

If you can afford it, make up a dozen or more of these packages so they are ready to go at any time. At a minimum, have at least a half dozen on hand. The more you have, the more ways you'll think of to distribute them. If you have too few, you'll hoard them and they'll do no good. You need to get them out there selling for you.

Here's an additional package that you can make up—a mini portfolio.

Make it small enough, say 4″ × 6″, so that you will carry it with you all the time. This portable portfolio should include sized-to-fit pictures of your artwork, a resume, and press clippings. It can be housed in a compact photo album (with polyethylene- or PVC-covered pages) you can purchase at a photography shop. You'll need only one so get a good one, maybe leather-bound, with pockets inside.

Brochure

Eye-catching strategies, such as using a heavy-coated stock, printed in fine-screen four-color process, plus spot varnish on your pictures, ingenious die-cuts, appropriate embossing, and foil hot-stamp, are great additions to make your brochure stand out but used in moderation. You can even add clever philosophical copy quoting a well-known art critic. By combining all the elements detailed here for your marketing package/midi portfolio, you've already created a darn good brochure, especially if you choose to bind the materials into a booklet.

Yet a brochure doesn't have to be a booklet. It can be no more than a single sheet of paper. If it's a single page, you can arrange the graphic and copy blocks so the paper will stay flat or fold in half or thirds without creasing the pictures. Reproduce one or several of your artworks using scanned or color-copier art and place it on an 8¹/₂″ × 11″ sheet of paper along with some copy taken from your biography and resume (be sure to include contact information) and you've got a reasonably priced, see-at-a-glance brochure you can hand out generously. If you can take slides or

Sean Moore, Painting Harvard Square. The way he likes.

Sean Moore's new oils and watercolors are scenes of and around Harvard Square.

The artist is from Newton, MA and studied at the Boston University School of the Arts and The University of Connecticut School of Fine Arts. He has taught at The University of Connecticut, Mount Ida College, The Art Institute of Boston. Now a senior lecturer at The New England School of Art & Design at Suffolk University, he is also a graduate instructor at Emerson College.

A member of the Cambridge Art Association, he is chairman of the show committee and curator of the Fall show *About Cambridge*.

The Cambridge pictures were painted over the past two years though the artist has lived or worked or played in and outside Harvard Square for the past twenty-five years. He often paints a given scene a number of times but in different media, at different times of day, in different seasons and from various points of view.

Often the buildings and other objects are rendered more solidly and with more attention to detail than the passing people; possibly reflecting the fact that in a college town the people continually come and go but the place, though constantly evolving, remains. Sean Moore is a preservationist in his works, painting buildings and views that will not be seen again.

"I paint night scenes because I can do what I want with light and shadow. In daylight I tend to defer to the single-source light of the sun. But when hundreds of electric lights glare and throw shadows, I can pick the ones I want, to suit my composition. If I need dark directional lines to bring the viewer's eye into the picture I can put in shadows whether any are showing. And of course I enhance highlights to establish focal points."

Sean Moore's work has shown nationally and regionally, winning various awards over the years and hangs in private and business collections.

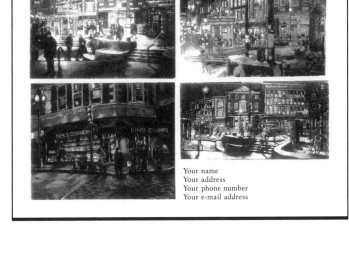

Your name
Your address
Your phone number
Your e-mail address

original art to an offset printer, that's good too, but again, it will be expensive, and you have to commit to a high print run to make it cost-effective.

Portfolio

Your main portfolio is a presentation waiting to happen. The portfolio is not redundant to slides or the brochure. A portfolio gives you another approach when it's inconvenient to set up a

slide projector and darken a room. And it shows your artwork much larger than a brochure or the photographs in your marketing package or mini portfolio.

Most likely, if you don't already have a portfolio case, you're about to get one. Here are a few practical tips to help you make your selection.

- Artist's portfolios come in two basic types. The first, with loose-leaf pages in transparent plastic slipcovers, is used by graphic designers, advertising artists, and illustrators. If you are a sculptor or other three-dimensional artist you can slip large photographs of your artwork in and out of the pages and therefore have the ability to customize your portfolio for each presentation. The second type of portfolio is empty, like a large briefcase. This kind is usually better for the fine artist. With this kind, you can mat drawings, prints, and photographs of your paintings and stack them inside unattached. The mat gives the look of a frame, which sets the artwork off nicely. Matting makes your work look more like fine art than just pictures. If you are a three-dimensional artist, matted photographs of your artworks are a refined way to present them. You can fit 10 to 12 pictures in your portfolio this way. During a presentation you flip them over, one by one, the way gallery people do when they show stacks of prints to customers. Both types of portfolios have inside pockets where you can store your marketing package folders.

- Do not buy a colossal portfolio like the ones favored by architects. (They're trying to be like Frank Lloyd Wright, who looked as though he could carry the whole building over to the client's office for approval.) Not only is a mural-sized portfolio cumbersome, but busy gallery owners will groan at its size. And when you land one of those things on the gallery owner's

crowded desk and open it to the wingspan of an F16, it invariably knocks over coffee or something else, and you're off to a bad start.

- Try a portfolio that is 16″ × 20″. It will hold 14″ × 17″ artwork nicely. If you want to show 11″ × 14″ artwork with a 3″ mat border all around, you'll have to go to an 18″ × 24″ portfolio. If you feel your work demands you go bigger, do so with caution. An impression of neatness and practicality isn't a bad first impression.

Get a Gallery

COMMERCIAL GALLERIES ARE for-profit enterprises; that is, they're in business to make money. Typically, they have a stable of artists with whom they have long-term relationships. Within this group, each artist usually gets a month-long solo show per year. The gallery usually has a combined group show once a year, where all the artists have a select group of their pieces shown. Some galleries close for one month every summer. Using this standard formula, that means that a gallery has a total of 10 affiliated artists. You can see there's not a lot of room to fit into a gallery.

Galleries make money by charging a commission on sales. This fee can range from 30 to 60 percent of the asking price; 50 percent is typical. Sound like a lot? It is. But in return, you get a first-class space, usually in a desirable retail area, the benefits of access to their regular customers, their mailing list, advertising, professional sales people, an opening reception, and the caché of their established reputation. Some galleries include all of these benefits in the price of their commission, especially if it's high. Others make the artist pay for all or part of the expenses of the

reception, printing and postage costs for advertisements, shipping fees, and more.

How to Find Commercial Galleries Where You Live

There are a number of ways to find local galleries in your area.

Gallery guide. The galleries in your area most likely publish a guide that lists all the galleries, with addresses, phone numbers, current shows, and pictures that will give you an idea of what style of art each gallery carries. This publication is a giveaway that can be found in many public places—libraries, art supply stores, adult education centers, bookstores, coffeehouses, colleges, and the individual galleries that are listed.

Newspapers. Check your local and big city newspapers. Current shows and openings will be listed in their calendar of events and/or arts section.

Books. Sources are listed under Galleries in the Marketing Resources section in the back of this book.

Yellow Pages. Your local phone book is a great free source of minimal information.

Whatever source you use, make a list of the galleries in which you'd like to show.

How to Create and Narrow Your List of Galleries to Solicit

Because of the small stable of artists each gallery represents and the large pool of hungry artists who want a gallery, getting into a commercial gallery can be hard, especially in big cities and art centers, but not impossible. Remember, every artist who is affiliated with a gallery got in there somehow.

Business people don't like to take chances with their money and time if they can avoid it. Gallery owners are no exception. They like to show artists who have already shown and sold. This appears to be a catch-22 since you have to get into a gallery first to get a track record. However, there are other ways to create a

track record. By following the other strategies outlined in this book, you'll be able to build your resume to show you have a proven track record of shows and sales.

Using your list of gallery names, visit each gallery and browse to find out what kind of art they show. Is it like yours? It's extremely unlikely a gallery that shows only postmodern abstract prints or glass sculpture will be the right fit for your impressionist paintings. There's no better way than a personal visit to find out what you need to know.

Here's a checklist of what to evaluate at each gallery.

- Sales people. Are they friendly? Helpful? Knowledgeable?

- Wall and floor space. Well lighted? Attractive space?

- Prices.

- Neighborhood. Is it safe? Trendy? Clean?

- Foot traffic. (Also make a note of the time of day and day of the week you visit to make this a fair comparison or to learn more information.) Is there a lot? A little? What kind of stores are nearby?

- General atmosphere and style of the gallery.

- Advertising and media relations.

Keep these items in mind while inside the gallery, but don't write down your evaluative comments until you leave the gallery. Jot down your impressions as soon as you leave each gallery so you won't confuse one gallery with another later on when you're deciding which galleries to approach.

Ask to be put on each gallery's mailing list. This will let you check out the efficiency of the galleries and the quality of their mailing pieces. If you never get anything in the mail, or if it's amateurish, you'll find this out.

If you're lured by galleries far away from where you live, have someone who is there, and who knows your art and art in general, look them over for you using the same checklist.

From your visits, the galleries' brochures, the local gallery guide, ads in the newspapers, and word of mouth, determine which galleries are a good fit with your work. Then make a list of these galleries. These are the galleries to approach.

Introducing Yourself and Your Work to Selected Galleries

Do not bring your work into a gallery without an appointment. Find out the name of the specific person to send your marketing package. Her name is often the name of the gallery. If not, you can find out this person's name easily by calling or by asking on one of your visits. Write a short, to-the-point, personalized letter and mail it off with your marketing package.

Wait at least three to four weeks before trying to follow up on your package. Gallery people are very busy. They're not just hanging around waiting for customers to walk in. They're cultivating buyers, helping their artists, arranging for transport, preparing opening receptions, promoting their shows in the media, attending to finances, and more. If they don't respond, send a short, polite note on the pretext of making sure they received your materials. You can enclose a small picture of your artwork to help refresh their memory of who you are. Remember that many galleries close for a month in the summer, usually August (except those operating in summer resort areas), so time your query accordingly. If you want to break the rule of not following up in person without an appointment, try to have a valid name to drop—"So-and-so suggested I stop by." Combining this with good timing and good art may bring you good luck.

Attend Openings

Some artists are more comfortable operating face to face, but there aren't many. If you're one of them, that's great. You can add another dimension to your offense by attending openings. Attend openings at the galleries in which you are interested. They're not as exclusive

as they look. If you're on the mailing list you might have an invitation. Don't worry if you're not—the gallery staff and the artists send so many invitations nobody knows who's who on the evening of the opening. If you dress the part, it's unlikely they'll turn you away.

By attending openings, you'll see firsthand what kind of party they throw and what sort of guests they attract. Is the crowd papered with students and other artists? Or are the limousines bumper-to-bumper outside? The dealer will be busy with customers and critics, but try to find someone who knows the dealer and will introduce you as an artist.

You can also drop into the gallery during the day just after the opening. Don't be pushy, but get to know the gallery staff. Complimenting the show is a good idea. Then, at the right moment, ask if you may leave slides.

Insider Trading

To get into a commercial gallery, of course it helps to have personal contacts in the art-trade infrastructure in a major art center, or at least in your area. It's great to have a close relative who's a museum director, art critic, or gallery owner, but most artists don't have such connections. The other strategies in this book are designed to get you known and also in the know—to move you from being an outsider to being an insider. With your ready marketing package and a nice body of work, you're prepared to make the most of your new gallery contacts.

How to Know If You're Ready for a Commercial Gallery

Your visits to the galleries in your area and other cities will give you a feel for what they show and how, or if, your work will fit in. Is your work the right fit for a particular gallery in terms of

- Style
- Quality

- Price

- Quantity (enough work of a consistent style)

You need to have a good-sized body of work; that is, more than will fill the gallery. (You should have enough to make the "back room" interesting. Some of the best gallery business is done in the back room.) The work should be in the same style. Some beginning artists think they need to show a variety of abilities, like when they applied to art school. Not so. Just as the "triple threat" school football player is rarely salable to the professional teams that want a specialist—the player who does one thing better than anyone—the all-media, all-genre artist is rarely considered suitable to the galleries.

If you work in different styles, don't worry—a lot of successful artists do. Just don't show galleries all your styles at first. Approach the gallery with one style at a time. They need to get a handle on you and your style. Don't confuse them. Make it easy for them, and the going will be easier on you. Obviously, *lead with your strong suit*—show them what you feel is your best work. Remember, the galleries are in business. They make money by consistently satisfying demand. You must show that you have a consistent supply to satisfy what you and your gallery both hope will be a consistent demand.

Give the gallery confidence. Galleries need to feel that you are focused and serious, not trying this out on a whim or a wish. They don't know you. They worry that even if your work is good, they might sell a few pieces to satisfied customers, have the customers come back for more or send referrals, then have to turn them away because you decided to go in some other career direction. They would be left with unsatisfied customers—the last thing they want. Galleries have to be careful about the artists they accept. They have to feel confident that you will work hard to develop your art and the reputation that helps sell it. Your solid marketing package will assuage their natural fears about a new artist and give them confidence in you, and should not show them too many different styles all at once.

After the gallery has success with your strongest and most commercially attractive style, you can introduce other work, perhaps in other media. Following up paintings with less expensive prints in the same genre is the ideal one-two punch. But even if your other work is quite different—say, macramé wall hangings—it may appeal to your established fans the way a fresh side of a known personality can enhance appreciation and enjoyment. It's still better if there's a consistency of aesthetic vision from one medium to the other. But if you're an artist with a vision that naturally produces a style, this consistency will be there regardless of the medium.

What to Do When You Get a Gallery

Educate yourself about the business relationship you're about to venture into before signing or agreeing to anything. Here are some tips.

- Check out sample contracts.

- Put everything in writing.

- Be careful of exclusive agreements.

- Make sure the agreement includes payment terms— how soon after a sale the dealer must pay you.

As incredible as it may seem, there are lawyers who volunteer services for artists. In the Marketing Resources section in the back of this book you'll find business and legal references to help educate yourself about this process before you begin.

What to Do When You Don't Get a Gallery

A lot of artists think a commercial gallery is a sine qua non for success. While the generally held idea that a writer isn't a real writer until he is published has some truth to it, a painter can still paint, show, sell, and prosper without benefit of a commercial gallery. Those temples of commerce are just the tip of the iceberg

in the business of art. *Most successful artists are successful without galleries.*

Among your friends, ask how many have visited an upscale commercial gallery in the past year. The answer might be none. Too many galleries have a snobbish, uncomfortable, and alienating atmosphere and some gallery people speak to customers in an abstract polysyllabic jargon that is so intimidating, even educated art lovers find it difficult. Most people don't buy most art in these galleries.

All is not lost if you cannot get a commercial gallery. You can get around them for now. There are plenty of options—there are co-op galleries, rent-a-galleries, alternative free spaces, and more. Most are inexpensive or free, and you'll be saving the big commissions charged by the commercial galleries.

Co-Op Galleries

Co-op galleries are owned and operated by a group of artists. Many such galleries are always open to new members. You pay membership dues that cover the gallery's overhead, and donate a few hours a month helping run the gallery. This can be kind of fun and informative—you get to see what the customers are like, what kind of art attracts them, what they like to know about the artists themselves, how they react to prices, and more. You can make a study of these things and put them to work for you to enhance your own sales.

The membership committee will want to see your artwork before the co-op extends membership to you. Before you meet with the committee, you should send your marketing package and completed application form—this will set you up for acceptance and will show them you have promotional savvy. They need good promoters, because they help promote the gallery itself.

Your membership gets you at least one solo show each year— maybe more depending on how many members are prepared to mount a solo show—and participation in group shows. In many areas, the difference in status between this and a commercial gallery show is negligible. Sometimes having a good co-op behind

you adds caché to your show. Plus, in a co-op gallery you'll get help with hanging, promotion, the opening reception, and gallery coverage.

Vanity Galleries

Vanity galleries, as they are scornfully known, don't have a regular stable of artists with whom they have a partnership or long-term relationship. These galleries are in a somewhat different business—they make money by renting their space to artists. Some, especially those in New York, are a downright scam. They cost way too much for an inferior space, offer no support, and generate no customers. About the only thing you get is a line on your resume that says you have had a solo show. But be warned— the cognoscenti have a condescending view of vanity galleries, and if the show is in a place no one respects, a solo show won't help. It may even hurt you by making you look foolish.

A few of these galleries may be on the up-and-up, providing a service that fills a demand, and doing it honestly. Even if you find a vanity gallery that doesn't have a bad reputation, or has no reputation at all, I'd still consider it as a last resort. About the only advantage, aside from the fact that you can get in, is that the cost of the show is a one-time fee, unlike the ongoing membership fee paid to a co-op gallery.

Some co-ops rent gallery space on the side to supplement membership dues. They give a regular series of shows featuring their member artists, but still have some open dates. In this case it is crucial to know whether they are willing to make their resources, such as their mailing list, advertising, public relations contacts, stationery, and people resources, available to you. If they aren't, you're no better off than with any other rent-a-gallery. You would be better off joining the co-op.

The above cautions don't necessarily apply to renting a space, such as a nice club, and throwing yourself a show. If it's done honestly, in the right spirit of fun, if a lot of people show up and you sell some artwork and get some media notice, your show will be a success. Just keep in mind that in the long run, it won't help

your career to have art world professionals dismiss you as a "vanity" artist.

Alternative Free Spaces

Artists and community cultural leaders in many cities have founded spaces that are alternatives to the establishment gallery system. They are nonprofit venues and depend for their support on arts and community grants, as well as private contributions. They are often well known and are frequented by commercial gallery owners, curators, dealers, critics, and the media.

Some of these spaces have been around so long they've become successful and have petrified into establishments in their own right, complete with entrenched cliques representing specific political or artistic agendas or an exclusive racial or ethnic makeup. If you find your local version stuffy and hard to crack, that is probably what's happened. (If you have trouble breaking into such a fortress, find out where they get their money and complain to the source.)

Other free gallery spaces include

- public libraries

- city or town hall

- local schools, colleges, and universities

- adult education centers

- local churches and synagogues

- social, civic, and sports clubs

- chambers of commerce

- historical societies

- local banks

- lobbies of office buildings

- corporate spaces

These are good public and semipublic spaces with a lot of traffic. If one of these spaces is already showing art regularly, contact the person in charge of coordinating the exhibition space. At a big library, the contact is likely the public relations person; at city hall or in a government agency, it's the public affairs officer; at a school, it's usually an art teacher. The Rotary, Kiwanis, and other civic clubs usually depend on a volunteer to coordinate exhibits. In any case, you can visit or call each of these places and ask for the name of the person in charge of the art. Eventually someone will explain the procedures to follow to get a show, or will send a brochure.

The procedures for exhibiting in a public space are pretty much the same as those for a commercial gallery, but they don't require that you're commercially established. Still, as a rule, the heavier your resume, the more attractive you will look. The people in charge of really small-time sites, accustomed to amateurs, are not used to a presentation as good as yours. Sometimes the people in charge at the coveted sites can't tell art from a water stain on the wall, but your chances for a competitive space will shoot to the top when they see your marketing package and see that you can demonstrate the following:

- You have professional promotional materials.

- You are affiliated with a known art association.

- You have shown in juried exhibitions.

- You have helped hang a show and put on a reception (volunteer work).

- Your work has some particular relevance to them. (If it's the city hall or chamber of commerce, it might be that your pictures are of local scenes, or relate to the history of the area, its economy, flora and fauna, or people. For a civic or religious group, you may be able to show a way in which your work relates to their mission. There may also be a "hook" in your biography.)

Some of these showplaces, like the library and corporate galleries, take care of publicity, and you pay for the opening reception,

invitations, food, and wine. But you're perfectly free to supplement their marketing efforts all you want. (See Strategy 5 for ideas on mailings, advertising, and public relations.)

The library, as a free alternative space, is not exactly an ideal place to get rich quick. The public doesn't come to a *free* library with a mind to buy things. However, this is a chance to build a relationship with the librarians and library staff. They are going to be a great free resource to you as information providers in general. Furthermore, having a good relationship with the librarians might help when you need special searches and information that only they can provide.

In fact, none of these venues are money changers in the temple or countinghouses of art commerce. But they're better than vanity galleries, by far. They are legitimate. The exposure is good. You can have a price list on hand, and a stack of your resumes for people to read or take away, and, in turn, you'll start to build recognition as an artist. The occurrence of a show itself, especially if it's a solo, will look good on your resume.

Some Less Obvious Venues

Some locations are suitable not for "having a show" but for ongoing exhibition of your work.

Doctors, lawyers, and other professionals' offices. Of course, selling art is not appropriate in these locations, but your artwork is shown in a dignified, quiet setting, and your name is on it. (I think the dentist's office has too many negative associations to be a good place for hanging your art, but maybe that's just me.) The doctor or lawyer or their receptionists may tell people who the artist is if someone asks. Perhaps they'll even let you leave some of your business cards, and, if anyone inquires about the art, will pass them along. Both my doctor and my lawyer have acquired a number of my paintings, drawings, and prints for themselves. Imagine your lawyer paying *you*.

Clubs. Private clubs, preferably those to which you belong, can be excellent showplaces for your artwork. You're known there already. It can be a win-win situation—you want to help make the

place look better, and they're likely to be amenable to your suggestions, especially if your work suits the nature of the club. If you paint seascapes or sailing scenes, your yacht, boating, or beach club would be the spot.

Free retail space. You can get into a vacant store, if only for a time, until it's rented or sold. Look around your town and in the real estate section of the newspaper. Most areas have both the traditional center-of-town retail district and the slightly out-of-town mall.

When you find an empty store, call the number on the window. Make an appointment to meet the owner or manager. The management company may be willing to take ridiculously low rent, or even a percentage deal. Why? Because something is better than the nothing they're getting until the space is rented. They benefit because the unrented store looks better with something lively inside. The whole building or mall creates a more successful impression when all the spaces look busy and occupied. An art gallery brings a little class and beauty to the whole neighborhood, too.

No one but the owners, their agent, and you will know the deal. When paying buyers or renters come along, they can tell them there's no problem: the art gallery is on a short-term lease and is planning to move anyway. They won't tell a prospective paying tenant they were letting the space for free.

Of course, *you* must suggest these things to them. They'd be foolish to offer you a free deal up front. They can't tell when you walk in the door whether you might be the answer to their prayers, such as a wealthy eccentric who wants to open a gallery to show her own stuff on a lark. You'll have to make it clear that this is not the case. You are a working artist looking for space. They know it's a break for you but they relate to enterprising people. And they know that the presence of your gallery can be beneficial to them. You can take this step, too, with one or more other artists and thereby share expenses and gallery coverage, making it an even more economical choice.

Carts and booths. Some malls have free carts, carts available for small rental fees, or carts where the user pays the mall a percentage of gross sales. Just walk into one of the shops and ask

who manages the building or the whole mall. You don't have to commit full time to these. Sometimes weekends or other prime times are enough. You can get friends and family to cover for you more easily than if you rented an entire store. They're less intimidated by a booth or a cart because of its informality. Booths and carts are fun for people watching, too. And you can network and build relationships with the other merchants, who might become your customers—another benefit of working out in the open.

Make sure you have a good selection of inexpensive artwork to sell at a cart or booth. Prints are perfect. Shoppers aren't buying original anythings at a mall. And selling from a cart is an exception to the always-framed rule. Obviously, you can sell your art cheaper if you sell it unframed. Then offer to frame, if the customers want, for more money. They can come back and pick it up later. You can have your space set up to do simple framing and mat cutting. Purchase a mat-cutting device at your art supply store. Or have ready-made all-in-one frames on hand that fit your standard-sized prints. This will give you something to do when traffic is slow, will make you feel productive all the time, and can become a nice little profit center.

Unframed prints can be neatly mounted on foam core with clear plastic covers on them. You can order clear plastic covers to fit the exact size of your work for a custom look. A 16" x 20" cover will cost about 25 cents. The clear plastic covers are a cross between envelopes and zip-top plastic bags, but stiffer. You slip the picture in one end and seal them tight. It looks very professional. (See the Marketing Resources section for company names.)

Retail Stores. So far, we've discussed locations where only art is shown and sold. But places where other goods are sold can be outlets for your art, too. Retail stores, specialty shops, and boutiques are in some ways even better venues to sell your art than the library or city hall, where people don't go to buy things. Shop around your area. Find a store that's a good fit with your art. If it's a small, informal place, you can probably talk to the owner about the idea. But, as with a gallery, writing is often better than catching them in the shop with a new idea while they're dis-

tracted. Send a short note with your marketing package ahead of time to give them time to think about your idea, to visualize your work in their shop, and to imagine the advantages of this business relationship. Your presentation must help their imagination. When invited, bring in your portfolio (because the store might not have a slide projector) with the matted works, plus a few framed pieces to show them what the display models will look like. They already understand the benefits to you, but you must help them understand the benefits of this potential relationship to them.

There are three usual ways this business arrangement can be set up. The store will

- take a commission on work sold,

- buy the work from you wholesale, then sell it retail, or

- consider the art an amenity to the store and take nothing on sales, but ask only that you replace the art sold.

Which deal do you want? Ask for the third option unless you need immediate cash and are willing to take half of the retail price for your work, in which case settle for the second option—take the money and run. Consider the first option as a last resort. Whichever deal you make, it's best to put it in writing. A very inexpensive book that includes forms you can use is *Business Letters for Artists*, by M. Stephen Doherty (listed in the Marketing Resources section under Contracts).

Furniture stores. Furniture stores and furniture departments of large department stores are great places to show your art. Stores that sell goods associated with home design or decoration are places that need art on the walls to enhance their setups and create a homey atmosphere.

Some stores have terrible art on the walls that would turn off most customers. Some owners just don't know any better, some think that good art will distract buyers from their goods, and still others think that nice art will take buyers' money—money that would otherwise be spent on furniture. If you're persuasive or

have the help of someone who is, here's what to tell furniture store owners. (Note: These benefits hold true for most retail establishments.)

- Good art elevates the aesthetic shopping and buying experience for their customers and will put customers in a better mood to buy.

- Good art enhances their products, makes the whole store look better and feel better, gives a classier presentation, and will help sell more of their goods.

- Good art is used by their competitors. (Name an establishment they are bound to respect or fear.)

Of course if your art really is kind of weird—if all your paintings look like Edvard Munch's *The Scream*—then it would probably be distracting in the average furniture or interior design store. If that's the case, look for offbeat specialty shops. There are costume shops where Charles Adams's work would fit right in.

If your artwork portrays a lot of landscapes and flowers, then a landscaping or florist shop would work; outdoor sporting scenes are a good choice for a sporting goods store or men's clothing shop; houses in picturesque settings would be ideal for a real estate office; seascapes and sailing images would be great for a marine and boating supply store. A friend of mine owned a western-wear store where the cowboy art of Frederick Remington and George Catlin would have been appropriate. If it isn't obvious to you what kind of store has the right fit for your art, ask your friends or other artists.

Note that less-expensive prints or posters are often more salable than original art in many of these settings.

Restaurants. Art provides many of the same benefits to restaurants that it does to retail establishments: art improves the atmosphere, enhances the dining experience of the customer, and provides conversation pieces for the diners.

Restaurants provide exposure in a well-cared-for environment where the viewers have discretionary funds and time to look at,

appreciate, and converse about your art. The benefit to you is a comfortable, well-fed—and sometimes well-lubricated—customer who is in a relaxed and even expansive mood.

If the owner agrees to this arrangement but won't let you stick cards to the wall next to your artworks, have a stack of price lists on hand with your resumes and/or brochures in a visible location. The simplest, cheapest way is to staple your price list (including title, medium, and size information) onto the back of your resume. Meet the restaurant staff and give them some background information on you and your work—a *spiel* they can tell the customers. If you encounter resistance, consider offering the restaurant owner a commission of 10 to 20 percent on sales. (Remember, 20 percent is cheaper than any other dealer's commission.)

Protect Yourself

When you place your work in a restaurant, furniture store, or other business, it's important to have a consignment sheet that shows what works you have in the business. This protects you in case the place burns down or gets repossessed. You'll find a sample form for showing in these semipublic spaces in Doherty's *Business Letters for Artists*.

A Closing Note on Style

It's fine to be aware of trends in the art world, but it's best to follow your own way in your work. Having a unique voice is more important than being in step as a way to become successful. The traditional American expressionist painter Jack Levine, whose success, as well as iconoclastic reputation, goes back to the 1930s, puts it well. "The idea of an artist working to keep his art *up-to-date* is just silly."

Join Art Clubs, Associations, and Organizations

ONE OF THE most underestimated and valuable resources an artist can have is membership in an art club, association, and/or interest organization. Yet many artists ignore these active and organized promoters. Most artists aren't joiners to begin with and tend to think of their local art association as social clubs for hobbyists. We either assume they cater only to the most traditional, ultraconservative art, or that they are insider elitist cliques dedicated to foisting incomprehensible avant-garde art on an unwilling public. Many do fit one of these extremes, but many do not.

There are many types of art associations. Start by looking up local art clubs, associations, and organizations in your area. Call each to get information about membership and what they can offer you, or go visit their gallery or office—either way, be sure to talk to someone who can answer your questions. Ask them to mail you a brochure, too. Then you'll have enough information to decide if

a particular group is for you. If you don't like one, try another one. It's worth your time. Why? Because these groups have

- Gallery space
- Publicized shows
- Mailing lists
- Promotional materials
- Established patrons
- Social events
- Art classes
- Guest speakers
- Opening receptions
- Information on what's going on in the art world

Memberships look good on your resume, too. The best ones don't accept just anybody. When they admit you, the established reputation and prestige of the association reflects on you and your artwork. It's like an endorsement or a testimonial. Listing such memberships on your resume or in your biography is another way to give potential buyers confidence. Remember, more people tend to want your artwork if they think others do.

Membership dues are usually small. Some have a kind of scholarship fund to cover artists who can't afford the membership fee—just ask. Most towns have their own art association, but you don't have to live in that town to join. Most associations are happy to have members from neighboring towns—it makes for a sense of community in the area and adds to their range of influence. I belong to a local association that is 56 years old and boasts members from all over the country, as does the more venerable Copley Society of Boston.

Join as many of these groups as you can. Get their newsletters and notices of shows in which they want you to exhibit. Your mailbox will be stuffed with invitations to show your work as

well as invitations to opening receptions, seminars, lectures, and other events. All of these activities provide you with potential networking and promotional opportunities. Some groups allow members access to their mailing list or will allow you to add promotional pieces to their mailings, sometimes without paying postage. (You'll read more about this in Strategy 5, Advertise for Free or Very Cheaply. As you progress through the strategies outlined in this book, you'll notice there is clearly overlap among these seven strategies. These overlaps create a synergistic effect that multiplies the benefits of your marketing.)

How to Get the Most Out of Your Membership

Here are some simple, but often overlooked, strategies to maximize your membership benefits.

Read the regular newsletter closely. Many times I hear members saying they didn't know about a particular show, they missed the deadline, they didn't realize the show was unjuried to members, or they were unaware of other opportunities, such as free seminars, demonstrations, tours, receptions, and other social events. It's likely this information was included in the newsletter, maybe even in several issues ahead of the events, or easily discovered by calling or stopping by the association's office. You must develop a habit of keeping track of these details.

Identify the events or activities you want to participate in. Put them on your calendar. Some organized successful artists keep a separate calendar of activities, dates, and reminders specific to their art life. Others find it better to integrate these items into their regular day-to-day schedule, along with picking up dry cleaning and birthdays, so they're sure to have them routinely before their eyes. Decide which method works best for you.

Volunteer. The more active you are in an association, the more you will benefit as other members, patrons, and officers of the organization get to know you. When some special advantage comes along, they're more likely to think of you than someone

they've never met or who doesn't contribute to the group. You can choose from a lot of volunteering opportunities, so you can select the activities that suit you best. Here are some examples of common volunteering opportunities.

- Gallery sitting. This was mentioned previously in Strategy 2, Get a Gallery, under the co-op gallery section. This gives you the same benefits.

- Help at juries. Getting an inside look at how the selection process works can help you determine what to submit next time. Plus, you get to meet the jurors, who are usually prominent figures in the art world in your area, such as museum curators, art professors, gallery owners, and art critics—people you might not otherwise get to meet and see in action.

- Help on pick-up and drop-off days. The association needs a few hands to register entrants, distribute identification tags, and more. Your help in these simple chores is noticed and appreciated.

- Lend a hand with mailings. Many associations have staff to handle the job of getting mailings out. However, some do not, or need extra help. By volunteering here, you'll get a sense of what sort of people are on the mailing list and how big it is.

- File slides. This is a simple sorting and filing job. This will show you what the other artists are presenting in the group's sale and rental program.

- Help with the newsletter. Some associations have staff who prepare the newsletter in-house and have it reproduced by an outside offset printer who, in some cases, is a member and prints it for free. The printer and other vendors may be given free membership. A small club may produce its newsletter on an office or a member's home computer and make copies on the association's photocopier.

- Serve on a committee. All art associations have committees. They determine and steer the various activities of the group. If you join one, you greatly increase your influence in the organization. Opportunities to chair these committees come along, too. Most art clubs and associations have show, finance, education, fund-raising, marketing, and newsletter committees.

Become a Member of Your Museum

Membership in your local museum offers a variety of benefits, including free admission, discounts in the gift shop or bookstore, use of the member's room and fine arts library, a newsletter, and invitations to special shows and occasional special event shows for which others have to buy tickets and wait in line.

Although there are many benefits to your museum membership, you aren't likely to get to show your artwork in a major museum. Traditionally, most museums have shied away from showing living artists so they are not accused of favoritism or, worse, manipulating the market. A museum's implicit endorsement of an artist or art movement is so powerful, the status and prices of that art can go way up.

For example, in the 1960s the Metropolitan Museum of Art in New York, then under the flamboyant directorship of Thomas Hoving, mounted a show of the work of living artists. They showed a lot of Pop Art, which was trendy and was being pushed by some of the New York galleries, whose stables included Roy Lichtenstein, James Rosenquist, Tom Wesselmann, Claes Oldenburg, and Andy Warhol.

The uproar came from critics, dealers, and artists whose art didn't get in. The argument was economic as well as artistic—if those in the show were the "ins" ("in" in the sense that their popularity shot up and their fortunes were made) then those not invited to be in the show were the "outs" ("out" in the sense of out of favor and therefore out of the market). They had a point. The art showing at the Met benefited from the hubbub, the attendant publicity, articles in art magazines, shows on public television—

and big sales. (Subsequently, a lot of artists sprinted to jump on the bandwagon, switching their style in mid-brushstroke.)

Whether museums should show current artists and art trends remains an interesting dilemma.

Despite such early misadventures, today more museums are mounting shows of contemporary art. This is more common in small-city museums and museums of contemporary art, which tend to be short on Rembrandts and more receptive to popular trends. This is less likely in the major encyclopedic museums.

If your museum has a slide registry, get in it. The curators will use it as a resource if they do mount an exhibition of contemporary art from your region. Some museums have talent shows and some have art-rental programs. Get the information you need and get your artwork registered.

Whether you show there or not, you must join your museum for its other benefits—you'll see a lot of great art, which is bound to improve your own, you'll meet people such as gallery owners, dealers, collectors, and critics, who can benefit your career.

STRATEGY 4

Get into Juried Shows

A JURIED SHOW is an art exhibit where artists submit work that, if reviewed and approved by the jury, will be included in the art show. Juries decide whether work is of sufficient quality and/or appropriate to the theme of the show. Acceptance is not guaranteed.

Entering juried shows is an important promotional step for an artist. Benefits include building up your resume, exposing the public to your art, getting a chance to win prizes, and being seen by influential art professionals and collectors. An artist not only gains a lot of opportunities by participating in a juried show, but with 10,000 to 15,000 juried shows in the United States each year, there are plenty of opportunities to participate in several.

Who's Running This Show Anyway?

Juried shows are sponsored by both public and private agencies. The federal government supports some, such as the Arts for the Parks Top 100 Exhibitions. Call (800) 553-2787 for information.

States, counties, cities, and towns sponsor arts festivals, often outdoors.

Private organizations like galleries, art associations, artists' co-ops, and some corporations sponsor juried shows all the time. Some are for members only, but most are open shows.

When you join an art club or association you can submit to these private shows as well as the public juried shows and possibly get your work in front of the public twice as often. Most shows are up for a month, but some local arts festivals take place on one or two weekends. A U.S. government agency traveling show or a museum traveling show could run a year.

In geographical scope, juried shows come in three sizes: local, regional, and national.

Local shows are the easiest to get in. Here, your work will be seen by people who know you. Local shows are sometimes judged by the slides artists submit; more often actual artwork is presented in front of the jury for their review. Local shows should have low entry fees because they're the cheapest to run.

Regional shows have larger audiences, and being accepted into these kinds of shows looks better on your resume than the local shows. Here, juries sometimes judge the actual artwork, but more often they judge slides.

National shows are the hardest juried shows to get in because they have the most competition. These shows look great on your resume. Because of the impracticality of sending actual works great distances, and storing and returning them, all national shows are judged by slides. This doesn't necessarily make it easier to get accepted, but it sure makes it easier to enter your work. You don't have to lug your work to the judges—that alone might make you more likely to enter. (Remember, the more shows you enter, the more chances you have to get in.) They'll ask you to send two to three slides in a regular envelope. Be sure to enclose a self-addressed, stamped envelope if you'd like them returned. If you're accepted, you'll have to pack and ship your artwork to the show, but you probably won't mind so much because you're in. So, whenever possible, go national.

In a juried show, the jury usually consists of only one person, such as a museum director or curator, an art critic, a gallery owner, or a distinguished professor. Limiting the judging to one person simplifies the process and theoretically gives the show a coherence and unity of vision. (That's what you say when your work is accepted. If your work is rejected, you'll say the one-juror process was flagrantly prejudiced and impossibly narrow in its scope.)

You can improve your odds if you know something about the juror. The call for entries usually names the juror. If it doesn't, write for a free prospectus or call and ask. If you are aware or can find out that a particular juror is known to have a bias toward Social Realism, and you're a Hard Edge, Color Field painter, put your effort into another show. If the juror is your kind of guy, send two entries.

Some shows have three or more jurors. This increases your chances that one juror will take a shine to your work, but your advocate can also be voted down by the other two. These juries have all the vices of committees—territorial conflict, hierarchies of eminence, axes to grind, indecision, and compromise. In any event, a bottom-line reality must be faced: if 1,000 artworks are submitted and only 200 can fit in the space, 800 have to go. Somebody must decide.

Judges usually start by triage—the obvious high-caliber work is stacked to one side and the equally obvious flea-market fare is set to the other side or hustled out of the room by volunteer helpers (could be a volunteer job for you); the "maybes" remain. If the quota is reached already by a feast of gourmet artworks, that's the end of it—no "maybes" and no flea-market fare gets in. But if there's room in the show for, say, 20 more pieces, the jury turns to the "maybes" and pores over them. As a volunteer picture carrier, I've seen jurors reshuffle and rethink their decisions, taking artworks out and putting them back in again, sitting down and staring back and forth between two pieces for 15 minutes, and generally agonize over their decisions from early morning until late at night.

Jurors don't do it for the money. They often get a modest hon-orarium, but some do it for free. Reasons vary: sometimes jurors do it to see a new body of art—maybe discover an unknown star—and some like to have a say about what the public sees as art. They hope to influence popular taste. But they don't make a living at it. They're doing their bit for art. You may not always like their decisions, but jurors are honest and usually give a rigorous day's work for about $200 and six pots of coffee.

There are a few kinds of shows to avoid at all costs. Here are the warning signs.

No jury rotation. Shows that do not have rotating juries, but instead have the same jurors every year for the same show, inevitably calcify into bias.

Insider juries. Shows in which the jurors are members of the sponsoring organization or the owner and staff of the gallery know the work of their friends and members and will make sure they get in, thereby reducing your chances (unless you are a member). Most shows go out of their way to get independent outside jurors.

Rolling jury. Submissions are judged as they come in rather than all together. By this system the number of accepted pieces needed for the show could be reached before your work arrives.

Tenuring. A few shows have reserved spots for regulars—artists who've been grandfathered in because they've been in the show for a long time (though originally juried in) and the sponsoring organization wants to encourage their participation. This is nice for them but reduces the number of places for you to fit in.

Uninsured shows. The prospectus should state clearly whether the sponsors are to shoulder financial responsibility for loss or damage to artwork in their care. If so, it will say something like "All works submitted are insured to a maximum $2,000." Some shows insure up to 80 percent of market value; others have full coverage. If you have doubts, call and ask or get it in writing.

Scams. A few shows out there are run purely to make money for the sponsors, rather than to support artists and enrich the quality of life for the public. These shows can be spotted if you know a few common earmarks: high entry fees, little advertising

or other promotion, no track record, little attendance, excessive hype in the call for entries, and no insurance.

If you see a number of these danger signals, ask around or check out the organization at your library. Another way is to call and ask a museum, newspaper, art school, or reputable art association in the area where the show will be held. If they've never heard of the show, it follows that nobody will attend anyway. If they know about it and warn you off, thank them.

How to Improve Your Odds of Getting into a Juried Show

Even if you know how a juried show is run and are cautious to judge the quality of a show before entering, you probably won't get accepted into every show you enter. Here are a few tips to help increase your chances.

- Read the instructions in the call for entries and the prospectus carefully and thoroughly.

- Fill in *all* the blanks on the application form.

- Do not submit artwork that exceeds the size and weight specifications.

- Submit only artwork that clearly corresponds to the stated theme and/or subject matter of the show.

- Submit no subject matter explicitly or implicitly prohibited by the sponsors.

- Send no artwork created in a medium specifically excluded from the show. (If it's a collage show, don't send an oil painting or an etching.)

- Label your slides according to the instructions.

- Make sure you mail your entry to the correct address. Include your full, correct, and legible return address so they can notify you of acceptance, prizes, or sales.

- Include your telephone number.

- Go to the show.

You've taken the trouble to find the show, send for the prospectus and application, prepare your artwork for display, pay the entry fee, and transport your artwork to the site. *Go to the show*, even if your work was not accepted. Swallow your sour grapes and go anyway. You'll get a better idea of what's out there and what kind and quality of art *is* being accepted. If your work did get in it's fun to go and hang around and hear what people say about it. They don't know who you are. We're lucky. Unlike performing artists, actors, singers, and dancers, we don't have to personify our work on display. We don't even have to be there. But go anyway, especially to the openings, because you'll meet people. I've met gallery owners, art critics, museum people, collectors, and artists' representatives—just the kind of people you want to know—at show openings. When you meet them, tell them you are an artist and *give them your card with a color picture of your artwork on it*. Yes, they will ask if you're in the show. If you aren't, simply tell them you're not in this particular one. They have no way of knowing if you submitted but were not accepted. The jurors themselves won't know. Even when a rejected piece was so spectacularly hideous as to be memorable for the sheer hilarity of it, nobody remembers the artist.

When you do get into a juried show, and you sell a work, have show personnel place a red sticker on it or on the title card next to it. You'll get a lot of notice when the people identify you. (Someone connected to the management of the show will always identify you to those who are looking.) If you have other art hanging in the same show, its desirability shoots up on the wanted meter. Of course, if you are a prizewinner, there's a similar buzz effect— the perceived value of your artwork goes up. The jurors usually pick the prizewinners for first, second, and third prizes, plus honorable mentions and best of show. If your work wins best of show, it means that a professional in the art world considered it the best artwork in the show—someone will want to buy it. The same is true for the other prizewinners. (Buyers, of anything, feel more

confident in a purchase when the value of their purchase is backed by expert opinion.) Some collectors will know the jury, so the very fact that your work was judged into the show carries weight.

If you win anything, don't stop there. Use your win to your advantage. The following strategies will help you build on your success:

- Get this award on your resume right away.

- Send out a press release right away, while the show is still up.

Where to Find Calls for Entries

You've probably found it easy enough to come across announcements of exhibitions that are about to open. And you've seen reviews and other coverage of these exhibitions while they're going on or after they're taken down. But in order to get *into* the shows you have to know about them well ahead of time. You have to be privy to the "Call for Entry." You can find these notices in art magazines, or from your art association, art school, art council newsletters, and from the Internet.

Magazines

Magazines written for artist's will regularly include calls for entries. These magazines include:

- *Art in America*

- *Art News*

- *American Artist*

- *Artist's Magazine*

- *Southwest Art*

- *Art New England*

- *Artworld Hotline*

Some of these magazines can be found at newsstands, but they have to be sophisticated newsstands or very large ones. You can also subscribe to these magazines, which is nice, but not cheap. To have access to these magazines without buying them, check with your art association, art school, or public library. In the library, you can photocopy the relevant pages or note the dates and contact information in your calendar. If the library doesn't carry the publication you want, they may be able to order it for you. (See Shows and Juried Competitions in the Marketing Resources section in the back of this book.)

Art Associations or Clubs

As a member of art associations and clubs you get notices of upcoming shows well ahead of time. Your art association is not only a source of mailing lists for you, but your association is *on* everyone else's mailing list. Any organization planning an open art exhibition knows that art associations represent a ready population of active artists who are prepared to submit their work to a juried show. So this is a regular place for these organizations to send their calls for entry.

Art School or College or University Art Departments

I'm chairman of the show committee at my main art association. At a meeting to plan a national show, some of the newer committee members were discussing where to send notices to get artists. I suggested the art schools and college art departments as one of the obvious places. They were dismayed. "But we don't want *student* work! We want professionals."

"Who do you think teaches the students?" I asked. (I'm on the faculty of the school of art at a university.) "Besides, a lot of student work is darned good." A show would be lucky to get their work. If you're affiliated with an art school or know someone who is, check the mail or bulletin board.

Arts Council Newsletters

Art councils are another great way to find out about juried shows. You can get listings of these newsletters from ArtNetwork for a fee: you can get a list of 500 art organization newsletters for $70 or a list of 1,000 art councils for $75. (This company offers many other lists such as art publications, college galleries, greeting card representatives, and more. Complete contact information can be found in the Marketing Resources section under Artist Representatives.)

The Internet

A great new place to find out what's going on in the art world is the Internet. Most organizations putting on an art exhibition will advertise their call for entries on the Internet. If you're not set up for it at home, you can access the Web on a school or library computer as well as at a business or computer rental center. Now there are even coffeehouses where you can access the Web while sipping espresso.

See Strategy 6, Get an Artist Representative to Work for You, for ways to promote yourself using the Internet, including how to get your own Web site where you can advertise your artwork, your shows, or anything, for free. (See Shows and Juried Competitions in the Market Resources section in the back of this book for more Web site suggestions.)

Who's Making Money in a Juried Art Show?

Juried art shows are not profit-making ventures. In a juried art show, artists who sell their work make money. The sponsors sometimes make some money, too. But most or all of the entry-fee money goes to the expenses of putting on the show. Even though the helpers are volunteers from the organization, the cost of professional hangers, advertising, printed invitations, mailings, food and drink, and, occasionally, rented space must be

met. Usually these expenses are more than the show makes, and the difference is made up by the sponsoring group's resources, commissions made on sales, supporting businesses, generous individuals, and, rarely, government grants. Profits, if any, go to the sponsor, which is usually an organization always in need of money, and whose main purposes are to support artists and enrich the cultural life of the community. So even on those occasions when your work isn't accepted into a juried show, you're doing *your* bit for other artists. Think of your entry fee as a contribution. If you don't get in, think about what you've learned that will bring you better luck next time. Don't give up, because the more you enter, the more you'll learn about the process and the more your work will get accepted.

When you do get in, you will beef up your resume, gain recognition, sell some artwork, and make you some hard-earned money. It's like making your own good luck.

How to Present Your Art When You Get into a Show

If you're an old hand, you already know how to present your art in a show. This section is more helpful for the beginner.

Frames

If you're an artist just starting out, and you're asking a low price for your artwork, you have to get free or do-it-yourself materials to display your work. Matters like framing, hanging, and hardware may seem obvious. But there are right ways and wrong ways to make these choices. It's important, in order to get the most out of your exhibitions and your sales, to do them the optimal way, if not the best way. The best way is to take your work to custom framers and have them do it. High-quality matting and framing adds immeasurably to the perceived value and desirability of your work. It can make the crucial difference between a sale and no sale.

If you can't afford first-class framing, I have some ideas for getting frames that can save you money and maximize your prof-

its. These can be especially helpful, even necessary, in lower-price venues. (Note: If you sell a high-quality work of art to a collector at a good price, they deserve and you owe them high-quality materials and workmanship in your framing. In these cases, I strongly recommend using a professional custom framer.)

Free frames. Most of the ready-made frames I buy for prints, watercolors, and drawings cost between $15 and $40. This includes glass and mat, but no wire. This is fine if your art business is up and running and your asking price for your art is between $100 and $200 for a print. When I'm selling multiples of the same print I can buy multiples of the same frame and have a uniform product. But this is not necessary when you can get them free. Here are several easy and sometimes fun ways I've used over the years. (No laughing allowed.)

Attics and yard sales. I've had a lot of luck with attics and yard sales, finding old frames people are throwing away or selling for a dime, a quarter, or two for a buck. They usually have goofy pictures in the frame, which you can throw away or keep around for laughs or paste into collages. Many still have the glass, screw-eyes, and wire in place. Clean them up and paint them if needed. Take them apart and clean the glass on both sides. (Somehow the inside of the glass on old pictures gets dirty, too—don't ask me how.)

I always spray paint the frames either black or white. Spray paint is best because it's quick and gets into the nooks and crannies from every angle, giving the frame a fresh finished look.

Of course, an antique look might be more suitable to your artwork. Some people actually like the look better and feel they're getting a "find" in addition to the picture. Customers are *much* more likely to buy on impulse if a picture is ready to hang. (More about that later.) This saves you about $25 that you would have to spend for a new ready-made frame from an art store, and you'd still have to take apart the frame, align your picture inside, and put it back together yourself. Keep that money in your pocket by using this method.

Frame shops and antique dealers. Look around the back door of frame shops and antique dealers. Frame shops make mistakes,

find imperfections, and get cancellations of custom orders. Antique dealers often get a pile of old frames they don't want as part of a lot they purchased for the items they did want. Their stores are cluttered enough, so they throw them out.

Trash. How do you feel about trash? I know a fellow who's a local policeman. He drives all around our suburb all day on the job, ever vigilant. He knows on which day each section of town has its trash picked up. At night he goes out in his own truck to the section having its trash collected the next day. It's an old and affluent suburb, so you get a very high class of trash: antique furniture, slightly obsolete appliances, and more. He's been doing this for years and has a great eye for good stuff that needs simple sprucing up or very small repairs. One could start a used frame shop with what he finds. If your town puts out a low grade of trash, you probably know a neighboring town that's a cut above.

Save more with ready-made frames. You can avoid custom frame shops except when necessary or price-justified. They do a great job, but you can do almost as good with ready-made frames. If you've been doing your pictures on random-sized surfaces that have to be custom matted and framed, stop. Don't do that. Your art will work equally well on standard sizes that slip right into standard-sized mats and frames.

I draw or paint my pictures, and size my prints, to standard sizes that fit the less expensive ready-mades (except for large oil paintings or when a composition demands otherwise). There's more than enough variety within the standard sizes unless you're working big, in which case the selling price should justify a custom job.

Some custom frame shops let you do the framing yourself on the premises. Let them cut the mat and frame because they do it better, with beveled edges and angled corners. And, of course, have them cut the glass. Then assemble the pieces yourself. Look for a frame shop that will let you do this, if you're good at it. Let them cut the corners, while you save the money.

If and when you can afford it, always use the best materials and get the best framing (or mounting, for three-dimensional artworks) you can. Most artists don't realize the importance of this

because we're better able to see right past the presentation to the work itself. Not all customers can do this. They see the whole package as one thing. And they're more confident judging frames, which they see as everyday objects not requiring special education, than the mysteries of artwork.

Use the Old Familiar Screw-Eyes and Wire to Hang Your Artwork

There are many ways to hang pictures today. These include hardware you attach to the picture that enables wires to extend vertically, straight up to molding or other hardware at the top of the wall. These are fine for professional installations, but potential buyers at juried shows will be put off by this method of hanging. It will be hard for buyers to visualize adapting this hanging contraption to their own homes. Most people are afraid of hanging pictures as it is. And framing? Forget it. Make it easy for them. Stick to what they know—screw-eyes with a horizontal wire on the back.

I've visited buyers weeks after they bought a framed picture and found the artwork still standing on the floor under the empty wall space intended for it. They don't know what kind of fixture to put in the wall to secure the picture. They're afraid to hammer a hole in the wall. They're afraid they don't know the correct height to hang the picture. (They're right. They usually hang too high. I think it goes back to their childhood experiences visiting museums or even at home, where they were always looking up at art.) I can tell when I'm standing in front of the empty wall with them. They look like they're staring up at the famous left-field wall at Fenway Park. While I'm looking straight ahead, they're looking at a point four feet higher, no matter how tall they are. If you are present when customers are buying, always offer to help with the hanging. They'll sigh with relief, and it could clinch the sale. If a sale involves delivering the work personally, bring your tools. While you're there, they may ask your advice about another empty wall.

Sculpture Presentation

A traditional white pedestal is still the best way to display sculpture. Even if your sculpture is big enough to stand on the floor, a low pedestal is a good idea. It sets off the work and makes cleaning around it easier and more likely.

Lighting

Lighting is an essential ingredient to making your work look its best.

Lighting Pictures

If you're showing in an established art gallery, the lighting should be all set. But if you're in an on-your-own situation, you'll need to know a little about lighting your art.

Regular light bulbs and regular fluorescent lights distort color. You can get color-corrected fluorescent or natural-light duplication bulbs (also called full-spectrum bulbs) to eliminate this problem.

Placing of Lights

If track lighting or ceiling tracks are in place, it is easier to make minor adjustments to the lights. The light fixtures should be placed $2\frac{1}{2}$ to 3 feet from the wall and about 3 feet apart. Don't aim the lights at the pictures. Direct the beam to where the wall meets the floor. This will provide diffuse illumination without glare.

Lighting Sculpture

Optimal lighting for sculpture is as variable as the shapes and textures of sculptures. Most lighting does not show off sculpture to its best advantage except in museums, where professional installation designers have worked out the best way to light permanent pieces. Go to a museum and see what they do. Sometimes lighting from directly overhead is dramatic. Some sculptures are themselves illuminated so that a darkened room is best.

If you create outdoor sculpture, you should know where it's going to be placed. You must visit the site, take into account the

surrounding elements (shadow-making trees and buildings), and the effects of the sun moving over the sculpture during the day. If possible, make a facsimile, if only with cardboard boxes. Assemble them on the site and photograph the mock-up. You'll be surprised not only at what you'll see, but how this will help you avoid costly mistakes and give you new ideas for the actual sculpture.

Nameplates

Juried and invitational shows take care of producing nameplates, but in many other venues, you have to do it yourself. No matter where you're showing, you must identify your artwork properly. In museums the artwork is identified by a small metal or plastic plaque on the wall or on the base of a sculpture. In shows, of course, the plaques cannot be permanent. But it's very important that they look substantial and authoritative. The price of the artwork will be included on them.

An inexpensive yet attractive method I use is to mount the typeset information label on a foam core mounting board. Sheets of foam core (available at any art supply store) come in colors. Black is dignified as a background for a white label with black type. I sometimes use red, for its attention-getting, cheerful look. (A bright color can help in a restaurant or other setting where it isn't immediately obvious that the artwork is for sale.)

The Label

The label should include the following information:

- Your name
- Title of the picture. (Always have a title. It gives the viewers a sort of mnemonic to help them remember what the art looked like.)
- Medium
- Size
- Date (Skip the date if the work is not recent—not from the past year or two. Buyers are used to consumer

goods. They think anything old is out of date, of a discontinued style, remaindered, and should be marked down.)

- Price (where and when appropriate)

Most artists put the title at the top. Unless there's somebody in charge who dictates otherwise, I put my name first. My pictures don't usually require much explanation, so I figure the viewer's first question after looking at one is "Who did it?" But if your art is somewhat obscure or conceptual, the viewer's first question might be "What is it?" A title can serve as a bit of explanation. (One time I observed viewers at an exhibition staring at an action painting with a lot of green and blue splashes. One viewer said, "What is that?" The other viewer, who read the label "View from Cobb's Hill" answered, "It's a landscape, of course.")

Most people seem to get some satisfaction from the idea that an artwork was inspired by something. This is even more likely in the case of nonobjective art. They want to increase their understanding of the art. Help them out if you can.

Don't use a typewriter to create your nameplates. This will make your labels look homemade. They're best done on a computer where you can use a real typeface that will make the label look professionally printed and official. Set them on the page so there will be enough white space to cut them out to about the size of a standard business card, which is $2'' \times 3^{1}/2''$ or a little bigger. Use a glue stick to mount them on the foam core base or print them on Avery card sheets or labels.

The Mount

If you're doing a few nameplates at a time, scraps of the best types of foam core, free at the art supply store, will do nicely. Foam core usually comes in $30'' \times 40''$ or $20'' \times 30''$ sheets. The smaller size is convenient. If you cut out $4'' \times 5''$ rectangles, you'll get 25 mounting backs, with no waste. A $4'' \times 5''$ card is fairly large, giving you about a $1^{1}/2''$ colored border around the label so they stand out well. Like any advertising communication, you want to

get the viewers' attention, bring them in to get the information, including the price, so they can think about buying your art. It's better to show them the price right away so they know if it's affordable to them. If it scares them off, they weren't buyers anyway. I don't like shows where the visitors have to go find a price list at the desk—that makes it too easy to walk away without ever considering a purchase.

Attach your nameplate to the wall using one of the following techniques:

- Use two-way tape. Try a small piece on the wall first. On certain wall textures, some of the tape sticks after you tear it off. You don't want to leave behind a problem.

- Fashion homemade two-way tape by turning a piece of regular tape, such as Scotch, masking, or electrical, into a loop, sticky side facing out. Press it onto the back of your mount. Press the mount onto the wall.

- If the hanging surface is soft, use tacks, pins, or thin nails to support your nameplates.

In all the above, keep in mind what you would like to see if you were a customer looking to buy art for your own home.

Advertise for Free
or Very Cheaply

THERE ARE A number of ways to get media attention without paying for it. Some of these options make use of existing resources, such as bulletin boards, can be used again and again, such as mailing lists, or offer endless potential, such as the Internet. This is an important strategy to get the exposure you need to make the money you want.

Art Online

Don't skip this section if you don't own a computer. Don't be scared if you're not computer literate. You don't have to be, any more than you have to know how to produce a newspaper or magazine to place an ad. You don't have to subscribe to an online service or Internet provider. You don't even have to *own* a computer to take advantage of the Internet.

Using the Internet to get your name and your work out there seems to be a must for all artists. It is not perfectly clear how much

good the Internet is doing artists, but the potential certainly is there. So it's worth giving you a rundown, at least on the freebies, of what you can get. What's to lose? People in the Internet industry say you can reach millions of "buyers." But there's a big difference between hits (browsers landing on your site) and buyers.

One way to get the word out about you and your artwork is to create a Web site. Your Web presentation can be aimed directly at a special-interest audience. Every "visit" you get could be a potential sale. Users seek sites and pages for information in specific areas from online search engines and from exposure to other marketing communications, such as mailings or business cards. (Note: If you have a Web site, or an e-mail address, you need to include this in all your business communication pieces, including your business cards, stationery, postcards, resume, and any ads you place.) This also makes you look market-savvy, big-time, and already successful. All of which makes your artwork more desirable, thereby justifying more serious prices.

There are many benefits to using the Internet to advertise yourself and your artwork. By using the Internet, you can

- Increase sales by increasing your customer base

- Make your artwork accessible 24 hours a day, every day

- Get customers who contact you when they are steps closer to making a purchase because they've already viewed your work on the Internet

- Increase profits from easy-to-manage and more frequent sales

- Stretch the value of your advertising dollar, expand your market, save you money and time, and create new revenue

Here are some facts about the people you can access through the Internet. Twenty-five percent of North Americans use the

Internet. People who use the Internet are affluent, educated professionals. Of those people who use the Internet

- 25 percent have incomes over $80,000
- 50 percent hold professional or managerial jobs
- 64 percent have a college degree

Source Information from CommerceNet/Nielsen Media Demographic and Electronic Commerce Survey, 1996 and 1997

On the Internet, you are reaching an audience that is more likely already buying art, willing to invest in art, and possessing the means to do so.

How to Get Your Own Free Web Site

America Online, CompuServe, and Prodigy

If you do have an online service or Internet provider, they often make space on the Web available to you at no extra cost. Most people don't use it: they use their service to browse or search the Web sites of sellers like you. The free Web space is measured in the amount of disk space your site can take up on the company's Web server computer. America Online customers can get 10 megabytes of storage. That's enough to create a site hundreds of pages long. Access the member services area and it will tell you how to set up a site.

You can put together a simple Web site in minutes that will work for you for years. Again, no need for HTML coding or CGI scripts. And no need to buy any Web design software. The online services provide page-making formats. That means they have sensible layouts, designed by professionals, all built in.

4 Good Ways to Get Your Web Site Absolutely Free

Here are six ways to get a free Web site without paying a subscription fee. Your addition to these Web sites helps them make money. Let them help you make money in return.

Tripod *www.tripod.lycos.com*

Tripod makes money by delivering viewers to major corporate advertisers. They will give you 11 megabytes of Web space in return for your theoretical viewership. (But like a television station, you don't have to watch the commercials just because you can.) Take the Web space and run with it. You can pay a monthly fee, as low as $10, for some basic listings, or a yearly fee, as much as several hundred dollars, for a fancier package and additional services.

You need an e-mail address to sign up for Tripod, but that's easy. Go to a resource called Hotmail (http://www.hotmail.com) and get a free e-mail account with an address that works with any Internet browser. Set up your free Hotmail account, then use the address to "buy" (meaning qualify for) your own Web page.

You don't have to know anything or do anything except sign up and send them your information and pictures. They do the rest. They design your Web site, provide marketing throughout the Web and in print advertising aimed at the art market, update and improve your Web site as technology develops, and provide traffic reports, direct Web interface, and contact through e-mail.

Tripod provides Web users (your customers) with a clean interface for searching, finding, and viewing details about artists, dealers, and works of art. Each listing is technically separate from the others, but they are all cross-referenced, or "linked" together, through search systems and navigational tools. They link you to popular search engines such as Yahoo!, Infoseek, and others.

Tripod secures your work with

- Image download protection, which prevents people from downloading images from your site

- Digital watermarking. Encrypted ownership information is embedded in images at their site.

- Restricted high-resolution imagery. High-resolution images are not on the server and are not accessible. The only images in the public domain are very low resolution and unsuitable for print.

They offer advanced bells and whistles like video, animation, and sound. Such features can entertain the user and enhance your presentation.

GeoCities http://geocities.yahoo.com/home/

Geocities has 600,000 members, and you can be one of them, free.

Angelfire http://angelfire.lycos.com

Angelfire gives you up to 30 megabytes and your own URL for free.

The Art Source www.theartsource.com

If you don't own a computer or have any money to spare, The Art Source is the option for you. You can get a free listing and more with this company. They also offer other services for an additional fee.

Artist/Item listing. They will list you and up to five pieces of art at no charge. Also at no charge, they will scan your artwork from slides or photographs as well as scan your picture or logo.

A Web site promoting you and your artwork. The Art Source will design a Web site, which you'll need for marketing beyond the audience that visits the Art Source Web site. $150/year.

Initial marketing package. The Art Source will submit your URL (Web site address) to between 200 and 300 search engines. $300 one-time fee.

Research, create, and register a domain name. They will help you obtain a Web destination, such as Yourname.com. $200 for the first 2 years, $50 every year thereafter.

Domain name hosting. They will host your new domain name or transfer your existing domain name to their system. You get a full domain with unique address, 25 megabyte storage, unlimited data transfer, Web traffic analysis, and links to the top five search engines. With this service you can get e-mail forwarded to you. Your address, if available, would be yourname@yourname.com. $600/year.

Beyond all that, they offer design and development services such as scanning, blowing up images, custom text and logo image,

image enhancements, and animated images. Fees for these services run about $100/hour.

The ArtSource.com also features an event calendar, artists' association listings, and educational listings. These, of course, require access to a computer.

You can also contact The Art Source at (888) ART-7224 or 1422 Delgany Street, Suite 10, Denver, CO 80202.

Even if you don't own a computer, there's no reason to be left out. You can put together a Web site at work, the public library, or (often) at your school, college, or university.

How to Get in the Media: Advertising and Public Relations

Traditional media advertising is not the usual marketing communications vehicle for the fine artist—it's too expensive. It can work well, however, when you have a specific promotion going, such as a show.

Publicity and other forms of public relations (PR) are better choices for promoting your artwork and yourself. When you get newspapers and magazines to give you some ink, or radio and television stations to give you some airtime, it looks like news—somebody else is blowing your horn. But if you can get free ad space, take it.

How to Get Free Advertising Space

Ask the sales representatives or advertising managers to send you the rate card and spec (specifications) sheet for their paper or magazine. Tell them you're in the art business, you have shows and art to sell, and you might become a paying advertiser.

When you get the rate card look at the conditions for advertising discounts, special sections, and special issues. Knowing the production specs and the prices will give you an idea of whether you can afford to buy ad space in the publication. Then call or see them and ask about the very special rates that come up unpredictably.

They might be cagey about special deals at first. Why should they give away, up front, what they hope to sell? But opportunities happen all the time and usually go to regular advertisers who are prepared to take advantage of them. They occur near press time, when the paper is composed and an odd space, sometimes even a whole page, turns up empty. This might happen because there was more copy than ads to support it, or some ad was withdrawn at the last minute. The sales representatives scramble to get their customers in there for whatever money they can. Failing that, the boss tells them to give it away as a make-someone-happy bonus because the paper would look foolish with a gaping white space that would look like a mistake. Merchants who don't have on hand a camera-ready ad for the appropriate size space are left wringing their hands and gnashing their teeth.

How to Take Advantage of Free Ad Space

You can take advantage of this free ad space by preparing several camera-ready ads for yourself. Make them small, medium, and large according to the sizes and proportions specified on the spec sheet. (If you don't have spec sheets, measure the actual ads in the publication. If necessary, get an art director or graphic designer to help you. It is absolutely crucial that ads for art look good.)

Make the ads generic so they advertise whatever it is you are usually selling or are prepared to sell at any time, to ensure that you can fulfill any response you get from the ad. If one of these chances comes along when you happen to be in a specific show, you must have show-specific material ready to go. Such opportunities may be rare in your local print media, but just one could save (and make) you a lot of money.

I have actually placed a full-page ad in a metropolitan weekly for *free* because I was ready. (Actually, I had a 7″ × 10″ ad, but it was proportional to the full page of this publication so it could be blown up to fill the space.) The regular price for this ad space was about $5,000. On another occasion, I received a full-page ad for the price of a smaller ad because, though I asked only for the smaller space, they had the full-page plate ready, and it was easier

to go with a full-page ad instead. I've gotten other freebies the same way, and the price is always right.

You must show artwork in an ad for artwork, and of course most newspaper reproduction is black-and-white. (You can get color only if your ad is going to print on the same sheet as something else that is set up to be printed in color.) The problem is that most colored paintings print terribly in black-and-white. From following Strategy 1 you should have good black-and-white pictures of your artwork and yourself that look interesting, tell or suggest a story, and make the reader say, "What's going on here?" or "This looks like fun," and "I want to see more of this," or "I am going to remember this information." (Refer to the section on pictures for news releases to find out about reproducing art for print publications. Or, if you have a professional publicist working for you, he or she will know how to handle this.)

Public Relations

Public relations is a discipline distinct from advertising. The two are done by people of different backgrounds, training, and often, temperament. Advertising is simple and straightforward. You buy space in the print media or time on the broadcast media. You make an advertisement and deliver it ready-made to the media. They print or air it as is. Advertising people don't have to finesse the media; people in public relations do.

The job of a publicist—someone who works in public relations—involves many tasks, including getting news coverage, mailing cards and notes of thanks to customers or others who help you, staging events, participating in trade shows, and making public appearances. But mostly a publicist writes news releases and sends them to the media hoping that editors will use them. The media may use these press releases as they are or will edit them. If you're lucky and have made your press release irresistibly interesting, they will use your information as the basis for, or as part of, a lengthier article or feature story. Because public relations people are not

paying for space in the media, they must be nice and helpful (and have good timing) to get the coverage they want.

How to Create Winning News Releases

You can create your own winning press releases. You already have generic news releases or releases from past events to guide you. When your news release involves a sponsor, such as a gallery, museum, art association, or prize committee, try to secure their permission to use their letterhead. It will get more attention and be taken more seriously than your own. If you do get permission to use organizational letterhead, still put your name and number under the contact information.

Use the layout illustrated on page 82; give your audience the information they need in the format they recognize—no need to reinvent the wheel here.

There are two kinds of press releases, and the information you include should be tailored to the type of coverage you expect.

The Free Listing

Local press will run free announcements of cultural events, but these are bare-bones notices. They cover only the five basic W's of journalism—the who, what, where, when, and why of a particular event or ongoing exhibition. You can try to sneak in a small hook or handle, but if it's too much information it will be cut. Worse, you don't want the editor to put aside your release for later editing, lose it, and miss the deadline. The address and deadlines for submission are printed at the beginning or end of the listings page or column. Beware: These listings are easily cut at the last minute depending on ad sales and stories that break close to deadline.

Full News Release

The full news release is intended for more than just a listing. This news release hopes to become an actual news item or even the basis for an article in the print media or a spot on the broadcast media.

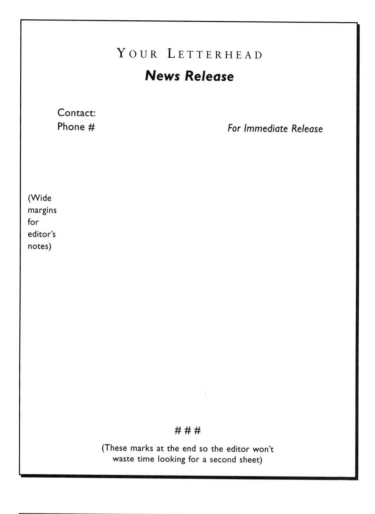

Even we artists can follow the five basic W's of journalism. Combine this with a hook or handle and you've written a news story. (Some artists will need help with this part. If you think you're one of them, ask a writer for help.) Here's an example of the copy.

Penelope Fairhaven shows watercolor riverscapes of the Concord River at the Emerson Gallery, 10 Monument Road, Concord, Sat., to benefit the Transcendentalist Movement. September 3–31. Open 1–6 P.M. daily. Reception Friday, September 9, 6 P.M. Free refreshments.

The hook: The hook is the part of your story that should be related to your biography but also be event specific.

Ms. Fairhaven is now ... Her new work is unusual in that ...

Think of something about your art, the venue, the occasion, or yourself that will give the publication or reviewer something on which to hang their hat. This hook will increase the chances they will use your news release and maybe even give it special prominence to make it stand out from the crowd. Refer to the hook you used in creating the biography part of your marketing package. However, the one you used there might be too generic to work as a hook for a current exhibition and not specific enough to your show for a particular news release. Ask your friends and coaches for ideas again. Here are some to get you started:

- Your art is of particular local or national interest.

- New! This is your first solo show at this location.

- Old! You or your work are familiar for some reason.

- Different! Your medium, technique, or subject matter are unusual.

A long-time oil painter and watercolorist, Ms. Fairhaven's recent works are excitingly executed in the new medium of water-based oil paint.

- You! Your background is unusual, you are a prize winner, a war veteran, senior citizen, or, like painters Tony Bennett or Martin Mull, you are better known for something else.

Ms. Fairhaven, descendant of Ralph Waldo Emerson, founder of the transcendentalist movement, is active as chair of the Walden Preservation Committee, which works to prevent real estate developers from building condominiums around Walden Pond.

Here are some suggestions of borrowed interest:

- The place in which you are showing is famous.

Next door to the Colonial Inn, where British troops ...

- The show is part of some larger celebration.

The Minutemen will re-enact the battle on the green in front of the gallery.

- The group with whom you are showing has interest.

Well-known members of the Concord Art Association will be showing their latest works.

- Another artist showing with you has good hooks. Don't just admire them—use them.

Supporting Information

You should send additional information with your press release. Most of this information should be in your marketing package (created in Strategy 1). This information includes:

- Short biography, including your hometown, schools, memberships, and other details the public can relate to

- List of awards, exhibitions, commissions, and other accomplishments that will show how popular and successful you are

- Press clippings, which show you're already established and newsworthy

Remember, most editors cut from the bottom up, so make sure the most important information is near the top of every supporting piece of information you send. Be sure to include a contact name and phone number that can be easily found. When your news release creates enough interest for a reporter or critic to call for more information, you must make it easy for them to get it.

Picture

A press release with a picture stands a 50 percent better chance of being used. (Note: The content of your photographs, whether action or straightforward, was reviewed in Strategy 1.) However, you can make it easier for a newspaper to use your photograph(s) by preparing them for publication. Do this by getting your photographs line-converted; that is, converting the continuous tones of gray in a black-and-white photograph into a fine screen of tiny black dots necessary for printing. A Photostat service, copy center, or computer scan can do this line conversion. This procedure makes your photograph camera ready, so the publication can shoot it as is. Newspapers print on soft, cheap paper that takes ink like a blotter. So they use a very loose screen. Ask the person doing the line conversion to screen for 65 to 85 lines per inch, or the equivalent in a computer scan.

If you do happen to be without black-and-white photographs when you need them in a pinch, you have to take a hard look at your color pictures to determine what will hold up. Place a color picture on a black-and-white copy machine to get an idea of what it will look like in black-and-white newspaper printing. You'll see in the original that red and green next to each other make a sharp distinction between forms, but if they are the same value they'll be the same gray in black-and-white reproduction. They'll show no distinction from one form to another in your picture—you'll get mush. So unless all your work is very high contrast, try to use black-and-white original art.

When your news release hits pay dirt and a newspaper or magazine wants to do an article or review, remind them that a piece about art with no pictures will be less effective, so they should send

a photographer along with the reporter. If the reporter arrives alone, they may intend to send a photographer later to shoot to the story as written. Just to make sure, give the reporter color slides and black-and-white prints along with your whole marketing package, so the reporter can refer to your biography, artist's statement, and exhibition list for interesting facts and details.

Where to Send News Releases

Create your own list of local and regional media, both print and broadcast, that might run a piece on you and your art. Be sure to include all the people you want to see it—critics, dealers, curators, potential customers, existing customers, school papers, alumni magazines, and club and neighborhood newsletters. (Tip: Don't be shy about visiting the offices of the local media, especially after a couple of mailings. Getting to know the editors and program directors will increase the chances of your material being used. Dropping off your press release in person is one way to do this.) Remember, even the smallest publications add up in your collection of clippings for your portfolio, so don't eliminate any due to size.

If you are in or near a major city—defined as having the four broadcast networks, two major newspapers, a city magazine, and a major professional sports team—send your news release to the major media. Each suburb usually has its own local paper and is often served by a chain that distributes suburb-specific editions. Local papers, radio stations, and cable television are very likely to run features on local artists. The subject is attractive because it seems different, yet is familiar. If you live near a state capitol, such cities often have Associated Press offices. Their presence increases your chances of national syndication, even if a piece about you and your artwork appears first in only the local media.

You may consider national media if you have a hook for them. For broader coverage, a more general hook is needed. Your art may be related to something outside itself, outside of art. Refer to your biography (developed in Strategy 1), hints for approaching exhibition sites outside the art world such as civic clubs, city hall, and church groups (developed in Strategy 2), and hooks suggested under "How to Create Winning News Releases" for ideas. Some

of these ideas can give you the advantage you need to transcend local media attention.

You may even send your release to specialized publications outside the art world if your art has an interesting relevance to them. Magazines like *Yankee Magazine* and *Down East* and their equivalents in other regions love nostalgia and Americana. Other magazines devoted to nature, antiques, fashion, homes, family, sports, textiles, or technology may be eager for art news that will interest, surprise, and please their readers.

For more ideas on how to expand your media horizons, use *The Readers Guide to Periodic Literature, Ulrich's International Periodicals Directory, Burelle's Media Directory, Gale Directory of Publications*, and many other reference articles listed in the Marketing Resources section under Media Listings. Also listed are directories that specialize in television and radio talk shows that feature artist guests and features. (Note: These books are all very expensive; your local library should have copies in the reference department that you may use on-site.)

When to Send News Releases

Many publicity opportunities will be spontaneous, such as when you've won something or made a high-profile sale, but when you're having a show or when you're in an important show, it's best to follow a publicity schedule. Setting a schedule will help you plan what to do and when to do it. Keep in mind that Saturday is the best day for an event. It is a slow news day so it is more likely to attract the media. A Saturday event is more likely to appear in the Sunday papers, which are the most widely (and deeply) read. Friday night is good, too. Here's a suggested schedule for you to use.

- **Three months before:** The facts of the show should be set so that you can choose your pictures for reproduction and prepare all the other necessary materials—such as photographs, invitations, press releases, posters, and any other advertising materials you are going to use.

- **Two months before:** Send full news releases to monthly publications by the first of the month. Be sure to

include photographs and biography. Send listings news releases to monthly publications. Include photographs if they use them.

- **Three weeks before**: Send full news releases and photos to weekly publications.

- **Send listings news releases to weeklies.** Include photographs if they use them. Send invitations to art editors and critics, and include cover letters if they've never heard of you. Enclose a news release if they weren't included in the previous mailings. Send to your whole list a mailing that includes announcements, invitations, posters, cover letters, and whatever you have that is appropriate.

- **Two weeks before**: Send full news releases to daily publications. Include photographs. Send news release to radio and television. Send second listings news release to weeklies.

- **One week before**: Send a postcard or some reminder to important invitees. Send third listings news release to weeklies. Send second news release to dailies.

- **Day before**: Call dailies, radio, and television.

- **Day after**: Send releases. The media are also interested in events right after they happen. Include people's reactions to the show or event as well as information on notable people who attended, and if the attendance was good, mention that. If someone from the media covered the event but not with a photographer, send them pictures that you took and send them along with your news release.

Your Story

When someone from the media attends your show or calls to interview you over the phone, you must be prepared. You need to have a practiced, coherent, and informative *spiel*. Remember,

most people will assume your art is a hobby unless presented with evidence to the contrary.

When someone asks "What are you?" and you respond that you're an artist, they will likely ask what kind of an artist you are or what do you paint, sculpt, or craft. If you hem and haw, don't have much of an answer, or if you give a vague or unsure response, like a lot of artists do, people will come away with the impression you're not much of an artist. In other words, if you can't say what you're doing, you'll sound like you don't know what you're doing. Instead of enduring an awkward moment that can make you feel pressured or resentful because you aren't ready with a coherent response, anticipate the question and you won't have this problem.

I used to think people wanted to know what my pictures looked like but didn't know how to ask. Our work is sometimes hard to describe in words that will help others see or understand what we mean. Simply answering painter, printmaker, sculptor, or craftsperson doesn't settle it. They still look at you, waiting, as if you've just restated their question but haven't answered it.

Most people think of art as belonging to two major types, realistic, or representational, meaning that it looks like natural objects such as in photographs, and abstract, meaning that it doesn't look like anything people are familiar with in their daily lives. Furthermore, people tend to think of artists as either amateurs or professionals.

By now you may be thinking you can avoid this problem by flashing your quick-draw business card or conjuring a mini portfolio to jump out of your bag. But even if you walked around inside a five-foot sandwich board of your artwork, people would still wonder about it. Having a business card is a big help, but it won't tell the whole story. People study a business card as if they contain a hidden clue to what they really want to know, but a business card doesn't say what kind of artist you are. What people really want to know is whether or not you are a professional artist. Does your artwork sell? Do you paint/draw/sculpt for a living, like a job?

After all the trouble you've taken to create a winning marketing package it would be a shame to blow it yourself in two

dumbstruck seconds. These questions are nothing to get tongue-tied over. All the elements of your answer and your story are right there in the marketing package. Your artist's statement in the biography section—especially the what, how, and why of your work—is the essence of your answer. Then you can state your hook or handle. Mention you sell through X and Y galleries, you're represented by X and Y, you're on the Internet, you're a member of a known art organization (name it), or something equally impressive, and that you have prints available. Finally, throw in a credit or two such as who bought your art, some prize you were awarded, and you're finished in 30 seconds or less with less than a hundred words.

Preparing this story is good practice for media interviews, face-to-face contact with gallery owners, grant officials, and collectors. Gather the information you need, compose your story on paper, read it out loud, then practice it on a close friend or spouse. Finally, test it out on someone who doesn't know your work. Listen to people's suggestions and make revisions that you think work.

Your story needs to distinguish you and your artwork from others. It should make your art understandable and likable and make the listener want to see it or see more. People should understand your work differently seeing it through the lens of your story. Make it short, interesting, and packed with information. Don't worry if it sounds too much like a sales pitch. People will interpret that you're a professional. You may think you're lowering yourself into crass commercialism, but the points mentioned are the things people who make money at regular jobs understand and people with money (who can afford to buy your art) will understand, too. They'll respect you for it. They will be much more likely to want some of your work, consider it a valuable commodity, and be willing to pay for it. Remember, people are much more likely to want your work when they're assured others do.

How to Get on Talk Shows

A good way to get yourself (not necessarily your artwork) in the media is to be listed in *The Yearbook of Experts, Authorities, and*

Spokespersons, published by Broadcast Interview Source. News people, program directors, and producers of daily newspapers check this source to find people who are prepared to give quotes, backgrounds, insights, and opinions and appear on television or radio programs. For a starting fee of $595 you will be listed in all six of their publications. More information is available in the Marketing Resources section under Media Listings.

Mailing Lists

There are a number of shortcuts and strategies that will help get the word out about you, your work, and an upcoming event. Mailing lists are a big help and, once set up, they can be used again and again. Your mailing list will overlap your news media mailing list and will include names related to sales, too.

Sources of Mailing Lists

Everyone you meet, exchange business cards with, or do business with is someone to add to your mailing list. Get the name, address, and phone number for every contact you have in the art world as well as all your existing business and social contacts. Exchange business cards with all the new people you meet and add these people to your mailing list, too.

Add new names to your mailing list as soon as you get them. If you have a computer, put them in your database while the contact is still fresh. If you don't, get 3″ × 5″ index cards and file each name by category—buyer, potential buyer, dealer, news editor, art critic, arts council/art association administrator, curator, publisher, and so on.

You can try to borrow or buy a mailing list from existing sources. Following are some ideas for places to search:

- People and organizations who already own your work
- Alumni lists
- Museums

- Galleries

- Art organizations

- Friends

- Phone book*

- Local business directory

- Church list

- Club list

- Local printer. I have a printer in a neighboring town who does a lot of mailings for his clients, which include many civic groups and the town itself. He has a computerized list of every address in town including 10,000 households for a total of 30,000 people.

You couldn't afford to send your mailing to so many people, but such a list—if you're given the right to use it—can be sorted according to any number of parameters. Ask a list owner, like the art association, if they can sort out a certain group, say, residents of your part of town, for a particular mailing you might want to make. There may be a fee attached to using this list.

How to Streamline Your Mailing Process

Automation

If you have a good, fairly new computer printer, you can use it to print mailing labels, cards, and envelopes. You'll have to type all the names into a database file first, but it's a one-time chore (except, of course, for regular updating and additions). Your com-

*Phone book? Of course most phone books are too big and most of the names are unqualified. But many towns have their own small phone book, often produced commercially by local businesses. I know of an artist who used to sell illustrations of family coats of arms using direct mail. He looked up the most common names (a market-driven idea) and then composed a direct-mail piece to, say, all the Smith family listings, with the family name seeded throughout so each letter looked personalized. And he did all of this marketing before he lifted a paintbrush.

puter may have a continuous feed option for envelope printing. If you don't have a computer you probably have a friend who does and will let you use it. If not, you might be able to do it at a copy center that rents computer time. They will show you how. You can archive your file at home on a disc.

Hand-Addressing Envelopes Can Get Results

If you have an automated system, your mailings will look like expensive commercial custom mailings. This is a great benefit, and automation will enable you to send out larger numbers more efficiently. But if you don't, your mailings at least can have a more personal touch if you address the envelopes by hand.

How do you sort your incoming mail? I believe most people triage their mail in about the same way: the obvious junk mail is put aside or sent directly to the waste basket; institutional-looking pieces of mail, usually requests or even strident demands for money, are put aside for later; and the ones that look personal, meaning a handwritten address and handwritten return address in the upper left corner, are opened with optimistic curiosity, or at least with relief. If you can't address each envelope by hand, a rubber-stamped return address is second best; printed stationery, with your actual name—not a made-up company name, unless recipients know this means you—is third.

Mailing Pieces

When art organizations (the ones you're going to join when following Strategy 3) sponsor a show, they send out announcements for regular shows and invitations to the opening-night reception— usually four-color glossy postcards, often with a group-rate postage paid. Even if they're not postage paid, postcard rate is less than letter rate, and you're still getting a nice marketing piece at no cost to you. The club will appreciate you sending announcements and invitations to members and nonmembers alike, so grab an armful. Take them home and send them to everyone you know.

When using these kinds of cards, put your name on them, or highlight your name if it's printed on the card. The art club

knows that the personal touch adds to their effectiveness because people will come to see particular artists more than a group of strangers. The art club will be grateful to you as a volunteer address writer. You'll be grateful for a source of free promotional material. Take the time you need to do this well. Get others to help or do it yourself while watching television. Remember, the more you use, the more you save and the more people will come to see the show. Even if your invitees don't come to the exhibition, your name gets out as a professional artist who shows. It's the perfect win-win situation. Everybody's happy. Every direct-mail marketing study has shown that response is overwhelmingly better to a personally addressed card than to a shotgun mass mailing addressed to resident.

The last time I volunteered to be curator of an art association show they reproduced a painting of mine on the cover of the newsletter in which the show was announced, and then again on the four-color glossy show announcement and opening reception invitation. They gave me a stack of cards to mail to anyone I wanted. If you find yourself in that situation you can contact the printer later for reprints, which are cheaper than the original order. They've already done the color separations and other set-up work. Printers keep these on file so they can handle reorders more quickly and easily. They can drop out the copy about the previous show and print new copy for another show or just your name and address and contact numbers—something generic but friendly. (Use *Photobackers*, postcard-sized labels that stick on the backs of the cards to cover the type as a quick makeshift conversion.) Now you can use them for anything that comes along. As mentioned before, it's important to be ready.

The association not only won't mind, they'll be thrilled at your initiative. They know it helps them as a group when their members promote their own careers because it enhances everyone's recognition. Remember to include "Member, (my wonderful) Art Association" on the back of the card and, for that matter, on most, if not all, of your printed material. The organization will appreciate the plug, and you benefit because you're showing

that you're connected. It's like a seal of approval. (That is, experts must think you're good because their names are on it.)

Bulletin Boards

Hang announcements or ads on bulletin boards at high-traffic locations. You don't even have to make a special trip to most of them—they are found in places you go regularly. Keep a few of your ad materials in your car or in your bag all the time so you'll have something handy when you spot a bulletin board. You'll find boards and be able to reach very different audiences at places such as supermarkets, city halls, beauty salons, art clubs, Laundromats, art supply stores, schools, book stores, chambers of commerce, and libraries. I suggest posting show-specific cards or flyers at these locations.

Pamphlets and Brochures

If you've made a small folder or gotten one from your art club or gallery, leave these in hotel lobbies. Visitors and other travelers almost always have discretionary money to spend, and they're looking for interesting local things to do in their free time. Remember how when you've been on vacation or a business trip your sense of a dollar was different? Hotels usually have a rack in the lobby meant to display advertising for local attractions. No rack? You can pick up folding cardboard holders designed for pamphlets and flyers at your stationer or art supply store for small change. They're blank, so you can put your own type and graphics on them. And use them in any location.

Real estate offices and local insurance brokers' offices are good locations, too, to leave a pile of material.

Answering Machine

Your home answering machine is a ready-made medium most artists let go to waste, yet it's so easy to use. Simply tailor the

outgoing message to acknowledge incoming calls in response to whatever you are currently promoting. Or make a generic outgoing message that mentions your artwork all the time. (Your regular personal callers know you are an artist and will simply leave their personal message at the beep.)

How to Double Your Response

Here are some ideas to build on the success that ads, posters, flyers, news releases, and mailings will bring you.

Free recorded message. Have your ads, flyers, posters, and business cards mention a *free recorded message*. Many people are reluctant to call in response to an ad. They think they're going to get some pushy salesperson with an annoying sales pitch who will ask personal questions about their income or where they live. So even if they're interested, they don't call. But a recorded message is safe. Callers can listen and hang up, or leave a message if they choose, because nobody is being pushy. People who call are better prospects because they've read your ad, responded to your ad, listened to your message, and left their name, address, and phone number.

Val-Pak. This marketing technique works especially well for artists who make and sell crafts. Val-Pak is the direct mail envelope you occasionally receive that is packed with offers for lube jobs, aluminum siding, baby pictures, and more. It's a fairly inexpensive, shotgun mass mailing with low-percentage returns, but if you have inexpensive prints or crafts, a Val-Pak ad might help publicize your name and product.

Information on how to place an ad is usually enclosed with all the other information and offers in the envelope. But you can piggyback or combine your ad with another advertiser for free or next to nothing because your insert adds a touch of class to theirs. This can be especially effective if your products or services are complementary to theirs, such as a picture frame shop, gift shop, or local print and poster gallery. You can arrange this on your own by contacting complementary enterprises that were included

in a previous Val-Pak and suggesting this arrangement. Perhaps you'll be able to work a barter deal—offer to let them hang your work in their place of business in exchange for the advertisement or give a gift of art to the owners of a store for their home. For more information contact (727) 397-4000.

Freebies. There's a lot to be gained from judiciously giving away your artwork or your services. Some might call it karma, but I think it's just a natural ripple effect of doing things. It used to be that when people asked me to volunteer something, I'd groan and think to myself, "These shysters are too cheap to pay. They just want to use me and waste my time for nothing. How can I get out of it?" Now I try to see these occasions as opportunities to do something good. When I do things to help people, sometimes good things come back to me. If not, I've still done something good, and this feels nice. Your instincts and experience will guide you in making these decisions. Err on the side of generosity.

Get an Art Representative to Work for You

ART REPRESENTATIVES ARE people who make money by making you money. They have client accounts—businesses or individuals—that they call on to help sell or lease your work. Having a representative can be very helpful—saving you time, money, and effort—but the catch is that you need to find one who's interested in your work. And know that sometimes having a representative won't give you an advantage when dealing with gallery owners, collectors, or grant committees, who may want to meet and deal directly with you.

Corporate Art Representatives

Businesses often dress their offices with art. Some buy art; others rent or lease art in much the same way they engage plant services, office equipment, vehicles, even temporary employees, and for the same reasons. Some businesses that rent or lease art get tax

advantages that are more beneficial than buying the art outright. Renting also allows a company to change the art in their offices when they want, while continuing the same lease arrangement.

Art representatives are sometimes connected with companies that specialize in selling and servicing art to corporate accounts. Some of these companies are well-established operations with galleries, framing and hanging services, and a professional sales force. These companies are always looking for artists. If you fit in with one of these firms, you'll have a professional sales force out there selling for you. Artist representatives charge a commission fee that is comparable to galleries.

How to Find Art Representatives That Service Corporate Accounts

You can find a corporate art representative in one of two ways— you can start with the art they place, or you can look up the representatives themselves.

Start with the Art

When you visit a business, an office building, a condominium, or a public building where you see a lot of professional-looking art on the walls, or sculpture in the lobby or on the grounds, ask where they get it. Do they buy it? Lease it? Does their architect, interior designer, or building manager handle the art acquisition? Somebody will know. If you don't have access to the CEO, start with the receptionist or a security guard. If they don't know, they often know how to find out.

When you find out who handles art acquisitions, call and ask if you may send your marketing package. What do they have to lose? They have to find artists somehow, and this is one of the ways they do it.

Locate the Art Representatives

Many representatives advertise in art publications or are listed in reference books. Contact the interior designers and architects who use the services of an art representative. (See the Marketing Resources section under Art Representatives.)

Art Print Representatives

Other representatives license your work to print houses, greeting card companies, and poster and calendar publishers. You'll find advertisements for these types of representatives in art magazines, through your art clubs, or listed in the telephone book. When you contact them, ask that a sales packet be mailed to you. The sales packet should include information about their artists, along with pictures, biographies, and statements. You'll see what kind of artwork they agent. They'll often send clippings from trade publications with notices of deals they've made with publishing companies on behalf of their artists. This packet should include references. Call one or two of these to find out how happy previous or existing clients are with the representative's services. The packet will give you an idea of how successful a particular art representative or company is.

If you decide a company might be a good match for you and your work, then send them your marketing package with a self-addressed stamped envelope. Let them offer you a deal. If they take you on and do well, you'll be making money in your sleep. (There are a lot of caveats to this rule when dealing with print publishers, which will be covered in Strategy 7.)

Private Client Art Representatives

A few private client art representatives do the same work as corporate art representatives, except they specialize in placing art in private homes. Unless you happen onto some of their customers, you'll find them in art magazines, through art clubs, and in the telephone directory. You can contact these representatives in the same way as the others and send them a copy of the same marketing package you send to galleries.

Art Association Sales and Rental Programs

Many art clubs act as your representative on a nonexclusive basis. This means you are not required to conduct every business transaction through them. To take advantage of this benefit of your

membership, make sure your art association has your slides on file. They should also have a current copy of your resume and black-and-white pictures of yourself for publicity. In fact, they should have a few copies of your marketing package on hand, too. When the sales and rental salesperson from your association goes out to pitch to companies, organizations, and public agencies, she uses slides because they're easily portable and look dramatic when projected on the wall. And if, in addition to slides, you've got a winning marketing package on file, she'll want to bring it along because it gives her another selling tool and makes you, her, and the group look good.

Sometimes clients come to the association office or gallery. That's where you want to have your original art—at least two or three originals or prints—framed and ready to hang. By having your art on hand at the association, buyers can just pluck a piece of your artwork off the wall, tuck it under their arms, leave money, and go. If it's sculpture that requires a stand, the stand should be ready to go, too. Having your artwork on hand and user-ready removes logistical or sales objections.

When you check it out, you'll find this little money maker is something many of the association members don't use. This, in turn, gives you a big advantage—you can get to the top of the list. As Woody Allen once said, "Showing up is 90 percent of success." When your work is on hand—slides as well as actual pieces—your work is what will sell. Taking advantage of this membership benefit is a great way to have your art in position to make money for you *all the time*, while you're happily creating in your studio.

Public Library Rental Program

Just about all libraries now have art programs. Patrons can check out artworks, just like they do books, tapes, CDs, and videos. Most libraries don't pay up front, but librarians tell the borrowers the art is for sale. That way, a potential but cautious buyer can

live with the art at home for a while and get comfortable with it before committing to a purchase.

Of course, if you have an especially friendly relationship with the librarians or other library staff, they're more likely to recommend your art to patrons. You may even want to donate a work of art to the library's collection. The library art program gives you another way to have your art and other people working for you while you're doing something else, like making more art.

Making Prints and Other Ways to Leverage Your Work

THIS STRATEGY OFFERS additional ways to spread the word about you and your art and ways to reach larger and sometimes different audiences with very little effort.

Slide Registries

A slide registry is a place where artists' slides are kept on file. Your local arts council, government agencies, museums, and art associations all have registries that you can be a part of. You can make your artwork available in many places at once by being a part of several slide registries simultaneously. Art world professionals, corporate buyers, and government agencies check slide registries whenever they're looking for artwork to fill a particular need. It's a good way for these people to see a variety of work more quickly and efficiently than visiting many galleries and studios.

You can expand your audience by participating in slide registries that reach far beyond the people who are able to view your original artwork. Call or write the registries to find out how many slides they will accept and what identifying information should appear on the slide frame.

When you send your slides, enclose a copy of your marketing package unless the registry prohibits this. (They may not want to store and maintain these additional materials until a visitor asks for them.) If buyers or a commission party is interested in your work upon seeing the slides, they'll want to know more about you. Your winning marketing package can help clinch the deal by giving the buyer confidence that you are a professional and are up to the job.

(See the Marketing Resources section for contact information on slide registries.)

Percentage for the Arts Program

The Percentage for the Arts Program is a government program that requires a percentage (less than 1 percent) of the budget for all new construction of public buildings or, in some cases, renovation of old ones, to be spent on art for the building. Sometimes the government agency handling this portion of the construction or reconstruction will buy your existing art. More often, you are awarded a commission to execute site-specific art. The art considered for such projects is found in slide registries, through limited or open competition, arts councils, or arts organizations. You can find out about these opportunities by keeping an eye on art publications and keeping in touch with your local arts council. (See Slide Registries in the Marketing Resources section.)

Grants

An arts grant is a *gift* of money (not a loan) to an artist or arts group for the purpose of advancing the cause of the artist or group. The recipients of grants must do only three things:

1. Seek out these opportunities (research),

2. Prepare the proposals to apply for the grants, and

3. Spend the money when you win the award.

The difficulty of the first two is the reason that most artists don't get grants. Another reason is that most artists think of the need for money as a general, overall, and constant need. To get a grant you must detail a *specific* need, for a particular purpose, with definite limits and a precise dollar amount. This requires planning and research.

It's OK if the purpose is self-serving, such as mounting an exhibition, creating a work of art, producing a catalog or other printed piece about your art, or studying something in the arts. Your aim can also be altruistic, such as teaching at or creating art for an arts center that serves children in need or a small museum of ethnic art. As long as your project is well defined, costs a specific amount of money that you don't have but need, and is something you are capable of, then you're ready to apply for a grant.

When you research grants, try to narrow your search to those where the qualifications apply to you. Many grants are given only to certain kinds of artists, such as those from a particular region, age, sex, or ethnic background. Don't waste your time applying for any grants where you aren't a perfect fit.

After figuring out what activity you want a grant to support and how much this activity will cost, the rest of the application process is mostly writing. Writing a grant proposal can be a challenging task. They must be tightly written, pithy, precise, and follow directions exactly. Your library and bookstores are packed with guides on how to write grant proposals. If you can't do it with the help of these excellent guides, you can hire a grant writer. (See Grants in the Marketing Resources section.)

Prints: How to Sell Your Art and Keep It at the Same Time

This section details the process of creating prints of your artwork. My intention is to encourage artists to think in multiples; that is,

reproductions of your art. Some sculpture media lend themselves to casting from molds made from originals; some do not. Many craftworks are reproducible. Artists should investigate ways to make copies of their art so there's more work to show and sell.

Selling your original art is fine. Most of us spend a lot of energy trying to do just that. But we've all experienced that letdown when a one-of-a-kind artwork is gone. You've spent weeks or months on a work. Sure, you get the money, but when it's gone (the money and the art), it's gone. Prints are a great way to solve this problem, leverage your artwork, spread yourself wider, and *make more money*. Prints are even more important if you don't sell many originals because you work slowly or part time and don't have enough of them available or your prices are too high.

There are two ways to go about producing prints and getting into the print business—do it yourself on your own equipment or with the help of a printer, or have an art publisher do it all.

If you're selling prints, especially through a print publisher, copyright your work. The United States government copyright office information line is (202) 707-3000. You can order forms by calling their hotline at (202) 707-9100 or print them from the Web at http://lcweb.loc.gov/copyright/forms. If you're going to manufacture or license your crafts, a design patent is a must. Get the details you need by writing the Commissioner of Patents and Trademarks, Washington, DC 20231 or go to the patent office Web site to search their database, apply for a patent, or check on the status of a current application at http://www.uspto.gov/Web/menu/tm.html.

If you decide to self-publish your prints, there are a number of advantages and disadvantages to consider.

Advantages of Do-It-Yourself Printing

1. You keep *all* the net profit.

2. You widen your price range, sell to lower-budgeted collectors, and broaden your customer base. The more collectors who own your artwork, the greater the chance you'll have of repeat sales and referrals.

3. You control the artwork.

Disadvantages of Do-It-Yourself Printing

1. You have to pay all up-front costs of printing.

2. You have to pay all the costs to market your prints.

3. You must invest a lot of time and effort to produce, market, and sell the prints.

4. You risk not selling your prints as quickly as you want, so until you do, you'll have to do without the money it took to make the prints.

Do-It-Yourself Printing Options

There are more ways than ever to make multiples of your artwork. Some of the new technologies are so miraculous and cheap that you'll see visions of sugarplums and self-publishing as the way to go. (You'll find suggested company names below and full contact information under Presentation and Sale of Art on Paper in the Marketing Resources section.)

Offset lithography. This is a good but expensive option. This traditional process, in which a printer scans your art and creates a plate from this scan that is placed on the printing press, is economical only if you print several hundred copies of the same image; this way the cost per print goes way down. For this approach to make sense, you have to be sure you can *sell* several hundred copies of the print. Get an estimate from a printer. Then figure how many you would have to sell at a given price to break even. Have you ever sold that many pictures before?

Color copier. This is your best-buy option, costing you about $1 to $2 per print. Xerox makes an excellent color copier. When properly tuned and adjusted to your picture, it makes copies so good you won't be able to tell the difference from your original from five feet away. Even the appearance of the texture of the canvas is reproduced if it's visible in the original. Close up, you can tell the difference in a watercolor only because the surface of the original picture is sometimes lumpy due to variations in wetness, drying time, and shrinkage that occurred on the watercolor

paper during painting. The print, of course, is smooth. To take advantage of this option, your art must be a standard size or look good on a standard size sheet. Size options include 8½″ × 11″, 8½″ × 14″, or 11″ × 17″. (I do a lot of 11″ × 14″ prints, which reproduce nicely.) Another benefit of using a standard size is that you'll be able to find cheap mats and frames to fit your artwork.

Reprochrome. These are color photo prints you can make from slides, transparencies, or reflective art. This process not only can reproduce but also enlarge or reduce the size of your art, and can be completed very quickly. It will give you a sharp, saturated image without the expense of an intermediate negative. Here's the *big* advantage: it can create an image from 8″ × 10″ to 4′ by 8′(!) and can make same-size prints from original art up to 30″ by 42″. Whatever the size of your art, it can be printed on glossy or matte-finish paper or clear film. The cost is about $20/square foot, but when making two to five copies of the same print, the cost drops by about a third. You can have your image mounted and/or laminated for an additional charge of about 25 percent. Call Charrette ProGraphics for a quote.

Supernova. This is a color inkjet print on photo-grade paper or film in very large sizes, from 36 inches to 12 feet. The maximum size of a Supernova image is 34 inches by 12 feet. Supernovas can be printed from scanned art, computer-generated art, or a combination of the two. One print costs about the same as a reprochrome, then the price drops by a third after that. Mounting and lamination cost about 25 percent more for each service. There's a quick turnaround time for this process. Again, Charrette is a reliable service to call.

Digital imaging. This process allows you to take an original piece of art, slide, transparency, or photograph and print it directly onto your choice of surfaces, including canvas, watercolor paper, even mylar. The cost is about $25 per square foot (for example, an 18″ × 24″ print costs about $75), but these get cheaper as you print more. You can have the prints mounted, laminated, or coated for a reasonable additional charge. I suggest calling Canvas Imag-

ing, Inc. for a quote. Digital imaging is sometimes called Micropix, Rosco, Repligraph, Linograph, or Acrylagraph.

Iris prints. This four-color, "continuous-tone" (not really) print process gets its sharp and accurate colors from its 1200 to 1800 dpi resolution. These are expensive—expect to pay $200 to $300 for a single print. Again, the cost drops with multiples. Contact Impact, Today's Graphics, or Digital Plus for quotes.

Pigment transfer. This is the most expensive per print printing option. This is a continuous-tone photographic print produced from digital files as light-stable pigments on mylar. These prints are guaranteed for 200 years against fading in a typical indoor setting. A 16″ × 20″ print runs about $425. After that, your image can be printed as many times as you want for about $145 each. Artists who are not seeking immortality can get prints with a 50-year guarantee for a more reasonable price: five 16″ × 20″ prints for $85 each; additional prints are $28 each. Contact EverColor Fine Art for a current quote.

Laser scanner (do-it-yourself). If you own or have access to a computer laser scanner, you've got a sleek new tool for making custom prints.

These are all great ways to self-publish prints. But what if you don't want to take on the cost and trouble of having prints made? What if you don't feel up to the expense, time, and effort of marketing and selling? And what if you're afraid of winding up with an embarrassing excess of inventory you can't move? Then a print publisher is a better choice for you.

Print Publishers

Print publishers may be a better choice for you if you don't like to take risks or don't want to take the time away from your art to handle the business details. Going to a print publisher is a tricky thing—it's not easy to put together a deal with them. They are usually far away, so it's not like walking into a local venue with your artwork after you've sent your marketing package and made an appointment.

You also have less control than if you sold your work yourself. Many artists worry that their royalties are not concomitant with sales. Be sure to create a contract with print publishers that includes the right to audit the company every year.

Royalties on print sales are usually 5 to 10 percent of the wholesale price. So if a print sells for $10 wholesale, your royalty will likely be 50 cents to $1. With this in mind, you should make a deal in which you are paid a healthy advance based on the number of prints the publisher intends to produce and market.

Alternatively, you can make a deal for a flat fee. If your prints sell like *Whistler's Mother* you won't get to share in the riches, but if they sell like ice cubes to Eskimos, you've still been paid, and you have no worries about royalties over the course of the contract.

Either way, your contract will have to take into account a lot of things besides payment, such as who owns the rights to the original, who insures the original art during transit, is the relationship totally exclusive or regional, how many artist's proofs will they print (this could be a hidden trap if they want an open-ended number), what happens to the plates and transparencies after the contracted number are run, and more. So before you make plans to be the next Currier or Ives, review the legal resources for artists listed under Contracts and Legal Matters in the Marketing Resources section and get some quotes from some print publishers.

Despite all the difficulties, a lot of artists do make money from partnerships with print makers. A few superstars shine. John Stobart comes to mind. His richly detailed paintings of 19th-century seaports and waterfront scenes are saturated with atmosphere, and his seascapes with wave-splashed sailing ships brim with movement and danger. His pictures are usually marketed as large, limited-edition prints and sell for hundreds of dollars. Stobart has sold the originals for more than $50,000.

Thomas McKnight's ubiquitous posters and prints of sunny Mediterranean verandas overlooking the bright blue sea have made him rich. His style, executed in flat planes of color, lends itself to hand-pulled, multi-pass silk screens or serigraphs. His

publisher also markets posters at lower prices at 2,000 galleries worldwide. Their easy accessibility makes them widely popular— even Bill Clinton and Hillary Rodham Clinton collect Thomas McKnight prints.

Whether you self-publish or find a good print maker, selling multiples of your work can be a vital component of your success. While keeping control and maximizing profit are the stuff that dreams are made of, professional print publishers can give you a reach and exposure you could not command on your own. The choice is up to you.

The 7 Winning Strategies of Successful Fine Artists

THE SECRET OF success is to get into the habit of marketing your artwork and yourself all the time. My hope is that this book has helped make these learned marketing skills second nature.

- When you get in a show, you automatically send out a news release about it and add it to your resume.

- When you complete a work, you get it photographed and consider whether it is suitable for reproducing and selling as a print or other copy.

- You subscribe to art publications or read them at the library to keep up with juried shows, grants available, free offers, art jobs, and other technical and business developments.

- You network in a variety of ways including visiting art galleries, joining and getting active in art groups, *making contacts*, getting a Web site, and developing a mailing list.

And, of course, keep producing and improving your art.

For the record, here are the winning strategies:

1. Have your marketing package *ready* to go *at all times*.

2. Market your art in a gallery, or some showplace, where it is seen *consistently*.

3. Market your art by participating in memberships *actively*.

4. Market your art by appearing in juried shows *recurrently*.

5. Market your art and yourself through advertising and publicity *continuously*.

6. Market your art through a representative or organization who will sell for you *constantly*.

7. Market your art through prints and other leveraging strategies *continually*.

By employing these strategies you'll have a better chance of making art for a living and becoming well known as a successful fine artist.

Marketing Resources
for the Fine Artist

THE FOLLOWING IS a list of resources that will help you with your strategies to become a successful fine artist. Because businesses relocate, change their Web addresses, or go out of business, please call to verify the source information.

Art Representatives

Art Business News
Phone (203) 656-3402

Art in America
575 Broadway
New York, NY 10012
Phone (800) 925-8059
Annual guide to galleries and museums in August issue, which is included in annual subscription.

ArtNetwork
P.O. Box 1360
Nevada City, CA 95959-1360
Phone (530) 470-0862 or (800) 383-0677
Fax (530) 470-0256

E-mail info@artmarketing.com
Web www.artmarketing.com
Lists of art editors, critics, representatives, consultants, museums, and corporations that collect art.

ArtREPS
20929 Ventura Boulevard, Suite 47
Woodland Hills, CA 91364
Phone (800) 959-6040 or (818) 992-4278
Fax (818) 992-6040

The Artist's and Graphic Designer's Market
Writer's Digest Books
F&W Publications
1507 Dana Avenue
Cincinnati, OH 45207
Phone (800) 289-0963
Fax (513) 531-4082
Web www.writersdigest.com

Business

Books

Baumback, Clifford M., Kenneth Lawyer, and Pearce C. Kelley. *How to Organize and Operate a Small Business.* Englewood Cliffs, NJ: Prentice Hall, 1988.

Grant, Daniel. *The Business of Being an Artist.* New York: Allworth Books, 1996.

Kuriloff, Arthur H., and John M. Hemphill. *How to Start Your Own Business . . . and Succeed.* New York: McGraw-Hill, 1993.

Whitmyer, Claude, Salli Rasberry, and Michael Phillips. *Running a One-Person Business.* Berkeley, CA: Ten Speed Press, 1994.

Business Organizations

Art Information Center
55 Mercer, Third Floor
New York, NY 10013
Phone (212) 966-3443
Consults with artists about how to get your art shown in galleries.

Service Corps of Retired Executives (SCORE)
Phone (800) 634-0245
Web www.score.org
SCORE offers a pool of 13,000 free consultants. It offers special programs for women.

Small Business Administration (SBA)
200 N. College Street
Suite A-2015
Charlotte, NC 28202
Phone (800) 827-5722
Web www.sba.gov
This is a government program that offers advice and small loans. Many areas have free consultants. Go to the listing of publications in the online library to find the free publications offered.

Volunteer Consulting Group (VCG)
300 E. 42nd Street
New York, NY 10017
Phone (212) 447-1236
Fax (212) 447-0925
E-mail boardinfo@vcg.org
Web www.vcg.org
This is a nonprofit organization that works nationally and regionally to strengthen the governing and management capability of nonprofit boards of directors.

Collectors

Carlin, John. *How to Invest in Your First Works of Art: A Guide for the New Collector.* New York: Yarrow Press, 1990. This book lets you eavesdrop on the buyers' point of view.

Frank, Jeanne. *Discovering Art: A User's Guide to the World of Collecting.* New York: Thunder's Mouth Press, 1997.

Maciolek, Cindi R. *The Basics of Buying Art.* San Jose, CA: Grand Arbor Press, 1995.

Contracts and Legal Matters

Books

Conner, Floyd. *The Artist's Friendly Legal Guide.* Cincinnati, OH: North Light Books, 1991.

Crawford, Tad, *Business and Legal Forms for Fine Artists.* New York: Allworth Press, 1999.

Crawford, Tad. *The Legal Guide for the Visual Artist.* New York: Allworth Press, 1999.

Crawford, Tad, and Susan Mellon. *The Artist-Gallery Partnership: A Practical Guide to Consigning Art.* New York: Allworth Press, 1998.

Doherty, M. Stephen. *Business Letters for Artists.* New York: Watson-Guptill Publications, 1993.
This book offers less formal (but legally binding) written agreements for artists to use with consignment showplaces, printers, publishers, models, portrait agents, mural commissioners, and dealers. This book includes full-page letters you can copy directly or edit and adapt to your business needs.

Leland, Caryn R. *Licensing Art & Design*. New York: Allworth Books, 1995.

Other Sources of Information

Copyright Office
Information (202) 707-3000
Form hotline (202) 707-9100
Web www.loc.gov/copyright
You can download copyright forms from this site.

U.S. Patent and Trademark Office
General Information Services
Crystal Plaza 3, RM2C02
Washington, DC 20231
Phone (703) 308-4357 or (800) 786-9199
Web www.uspto.gov
Provides information and forms on how to register your trademark with the Patent and Trademark Office.

Volunteer Lawyers for the Arts (VLA)
1 E. 53rd Street, Sixth Floor
New York, NY 10022
Phone (212) 319-2787
Fax (212) 752-6575
Web www.artswire.org/artlaw/info.html
To order a directory of local offices:
251 S. 18th Street
Philadelphia, PA 19103
Phone (215) 545-3385

Foreign News Media

Directory of Foreign Correspondents in the United States
Washington Foreign Press Center
898 National Press Building

14th & F Streets NW
Washington, DC 20045
Phone (202) 724-0032
This is a *free* publication compiled by the United States Informa-
tion Agency (USIA). Call or write for a free copy. Lists consulates
of foreign countries, especially those in New York, Los Angeles,
and Washington, D.C.; includes lists of other publications.

Ulrich's Guide to International Publications
You'll find a copy at your local library. While at the library,
consult foreign publications, too. The U.S. correspondent is
often listed in the masthead.

Foreign Exhibits

United States Department of State
2201 C Street NW
Washington, DC 20520-0258
Phone (202) 647-5723
Contact for information on the Art in Embassies program.

Foreign Residencies

Arts International
Institute of International Education
809 United Nations Plaza
New York, NY 10017
Phone (212) 984-5370
Fax (212) 984-5574
Web www.iie.org/ai/

The Foundation Claude Monet
Institute de France
Academie des Beaux-Arts
27620 Giverny, France
Phone 33-32-51-28-21
Fax 33-32-51-54-18

Gullong, Jane M., and Noreen Tomassi, eds. *Money for International Exchange in the Arts*. New York: Allworth Press/ACA, 1992

Galleries

Art Now Gallery Guides
P.O. Box 5541
Clinton, NJ 08809-5541
Phone (908) 638-5255
Web www.gallery-guide.com

Artist's and Graphic Designer's Market
See listing under Art Representatives for contact information.
Call for a free brochure of all the books they offer.

Grants

American Council for the Arts
1 E. 53rd Street
New York, NY 10022-4201
Phone (800) 321-4510

ArtWorld Hotline
Phone (916) 432-7630
Monthly newsletter.

The Foundation Center
79 Fifth Avenue and 16th Street
New York, NY 10003
Phone (800) 424-9836 or (212) 620-4230
Fax (212) 691-1828
E-mail library@fdncenter.org
Web www.foundationcenter.org

Going for Grants
New York Foundation for the Arts
155 Avenue of the Americas
New York, NY 10013-1507
Phone (212) 366-6900
Web www.nyfa.org
Offers a variety of programs for fine artists including fiscal sponsorship, fellowships, visual arts hotline, quarterly newspaper, and more.

A Guide to Proposal Writing
The Foundation Center
79 Fifth Avenue and 16th Street
New York, NY 10003
Phone (212) 620-4230
Fax (212) 691-1828
Web www.foundationcenter.org
The price of this publication is $34.95.

Grants for Women Artists
For Us Publications
P.O. Box 1789
New York, NY 01127
Phone (212) 932-9568
Web www.grantlady.com
This is a monthly internet newsletter available by subscription only, for $25/year or $2.50/issue.

NAEA Scholarship Book
National Art Education Association
1916 Association Drive
Reston, VA 20191
Phone (703) 860-8000
This directory costs $15.

*National Directory of Grants and Aid to Individuals in the
Arts, International.* 8th ed. Washington, DC: WIAL, 1993.
A directory for painters, sculptors, printmakers, and art histori-
ans to locate organizations and institutions that give funding to
individuals. Contains listings of most grants, prizes, and awards
for professional work in the United States and abroad, and
information about educational funding. Indexed by discipline,
indicating if aid is for education or profession.

National Endowment for the Arts (NEA)
1100 Pennsylvania Avenue NW
Washington, DC 20506
Phone (202) 682-5400
Web www.nea.gov

National Endowment for the Humanities (NEH)
1100 Pennsylvania Avenue NW
Washington, DC 20506
Phone (202) 606-8400
Web www.neh.gov

Money for Artists
Center for Arts Information
625 Broadway
New York, NY 10012
For New York State artists only.

Niemeyer, Suzanne. *Money for Visual Artists.* New York:
Allworth Press/American Council for the Arts, 1993.

Foundation Libraries

These libraries have a database of available grants and donors,
books on grants and foundations, and sponsors of grant-writing
seminars.

Atlanta

50 Hurt Plaza
Atlanta, GA 03030-2914
Phone (404) 880-0094

Cleveland

1422 Euclid Avenue
Cleveland, OH 44115
Phone (216) 861-1934

New Haven

70 Audubon Street
New Haven, CT 06516
Phone (203) 777-2386

New York

The Foundation Center
79 Fifth Avenue and 16th Street
New York, NY 10003
Phone (212) 620-4230
Fax (212) 691-1828
Web www.foundationcenter.org

San Francisco

312 Sutter Street
San Francisco, CA 94108
Phone (415) 397-0902

Washington

1001 Connecticut Avenue
Washington, DC 20036
Phone (203) 331-1400

Greeting Cards

The Artist's and Graphic Designer's Market
See listing under Art Representatives for contact information.

Directory of Greeting Card Sales Representatives
Greeting Card Associations (GCA)
1200 G Street NW
Washington, DC 20005
Phone (202) 393-1778
$95 plus $4.95 S/H charge. Write a letter to request a copy.

Directory of U.S. Greeting Card Sales Representatives
Terrier Marketing
6323 SW 60th Avenue
Portland, OR 97221
Phone (503) 245-5703

Fink, Joanne. *Greeting Card Design.* Glen Cove, NY: PBC
Graphic Details, 1992.

Greetings Today
Phone (800) 627-0932
Trade publication with ongoing news of the business.

Party & Paper Retailer Magazine Online
Web www.partypaper.com
Trade publication with ongoing news of the business.

The Rep Registry
P.O. Box 2306
Capistrano Beach, CA 92624
Phone (714) 240-3333

Szela, Eva. *The Complete Guide to Greeting Card Design &
Illustration.* Cincinnati, OH: North Light Books, 1994.

Wigand, Molly. *How to Write & Sell Greeting Cards, Bumper Stickers, T-shirts, and Other Fun Stuff.* Cincinnati, OH: Writer's Digest Books, 1992.

Internet Resources

Books

Lewis, Herschell Gordon, and Robert D. Lewis. *Selling on the Net: The Complete Guide.* Lincolnwood, IL: NTC Business Books, 1997.

Shiva, V.A. *Arts and the Internet: A Guide to the Revolution.* New York: Allworth Press, 1996.

Web Sites

www.art-smart.com
Art-Smart is a highly searchable database of art. See original and print artwork from $5 to $50,000, from all over the world.

www.artbusiness.com
This company provides complete art business information for art collectors, artists, and fine arts professionals. They appraise works of fine art and offer expert advice and consulting on buying, selling, and collecting.

www.artlinktgi.com
TGI Art Marketing offers a cost-effective way for artists, agents, fine art photographers, and small publishers to exhibit their art at major national and international trade shows.

www.artsusa.org
Downloads of helpful information about the art world.

www.genart.org
Gen Art is a national nonprofit organization that showcases the best emerging talent in film, fashion, and the visual arts. Gen Art gives culturally savvy audiences access to this talent through the production of fashion shows, film festivals, art exhibitions, and other events.

Mailing Lists

ArtNetwork
See listing under Art Representatives for contact information.

Media Listings

Library Reference Suggestions

These titles are expensive to purchase. Try your local library for unlimited in-house use.

American Art Directory

Bacon's Publicity Checker

Burelle's Media Directory

Editor and Publisher

Gale Directory of Publications

Newsletters in Print

Oxbridge Directory of Newsletters

The Reader's Guide to Periodic Literature

Standard Periodical Directory

Ulrich's International Periodicals Directory

Listings Available for Purchase

National Talk Show Guest Registry
P.O. Box 4355
Blue Jay, CA 92317
Phone (909) 337-5151
E-mail Resrchdept@AOL.com

New York Publicity Outlets. $149.50
Metro California Media. $149.50
Published by Public Relations Plus.
P.O. Box 1197
New Milford, CT 06776
Phone (800) 999-8448 or (203) 354-9361

Power Media Selects. 3,000 media contacts, $166.50.
Talk Show Selects. 700 shows, $185.00.
Yearbook of Experts, Authorities, and Spokespersons. $39.95.
These titles are published by Broadcast Interview Source, Inc.
2233 Wisconsin Avenue NW
Washington, DC 20007
Phone (800) YEARBOOK or (202) 333-4904
Fax (202) 342-5411

News Releases

Abbott, Susan, and Barbara Webb. *Fine Art Publicity: The Complete Guide for Galleries and Artists.* New York: Allworth Books, 1996.

Blade, Nicholas E. *Marketing Without Money: 300 Free and Cheap Ways to Increase Your Sales.* Wolloughby, OH: Halle House Publishers, 1999.

Borden, Kay. *Bullet-Proof News Releases: Practical, No-Holds Barred Advice for Small Businesses from 135 American Newspaper Editors.* Marietta, GA: Franklin-Sarrett Publishers, 1994.

Falkenstein, Dr. Lynda. *Nichecraft: Using Your Specialness to Focus Your Business, Corner Your Market, and Make Customers Seek You Out.* New York: HarperBusiness, 1993.

Levine, Michael. *Guerrilla PR: How You Can Wage an Effective Publicity Campaign Without Going Broke.* New York: HarperBusiness, 1993.

Yale, David R. *Publicity & Media Relations Checklists: 59 Proven Checklists to Save Time, Win Attention, and Maximize Exposure with Every Public Relations and Publicity Contact.* Lincolnwood, IL: NTC Business Books, 1995.

Yudkin, Marcia. *Six Steps to Free Publicity and Dozens of Other Ways to Win Free Media Attention for You or Your Business.* New York: Plume, 1994.

Personal Inspiration

Bayles, David, and Ted Orland. *Art & Fear: Observations on the Perils (and Rewards) of Artmaking.* Santa Barbara, CA: Capra Press, 1993.
Explores success blocks, why artists give up, and how to assert your future.

Gawain, Shakti. *Creative Visualization: Use the Power of Your Imagination to Create What You Want in Your Life.* Springfield, VA: Nataraj Books Inc., 1998.
This book includes techniques for eliminating blocks to success.

Jampolsky, Gerald G., and Diane V. Cirincione. *Change Your Mind, Change Your Life: Concepts in Attitudinal Healing.* New York: Bantam Books, 1993.

Sher, Barbara, and Annie Gottlieb. *Wishcraft: How to Get What You Really Want.* New York: Viking Press, 1979.

Postcards

Go Card
73 Spring Street
New York, NY 10012
Phone (212) 925-2420
A package deal that includes printing and distribution of the finished cards. For .08 per postcard, they'll print a minimum of 30,000 four-color postcards and distribute them to postcard racks all over New York City.

Hot Stamp
541 N. Fairbanks, Suite 1890
Chicago, IL 60611
Phone (312) 644-0703
Fax (312) 644-1049
In 14 major U.S. cities including Los Angeles, New York, Chicago, San Francisco, Boston, and others. Call for current rates.

Modern Postcard
1675 Faraday Avenue
Carlsbad, CA 92008
Phone (800) 959-8365
Fax (760) 431-1939
Web www.modernpostcard.com
$95.00 for 500, $4^{1}/2'' \times 6''$ four-color postcards.

Photobackers
World Market Products
211 East 5th Street
Tempe, AZ 85281
Phone (480) 967-2935
This company sells postcard-sized labels that stick to the back
of photos or color copies, turning them into postcards. These
labels are also useful for covering the back of printed postcards
that have wrong information, such as that from a previous
address or a bygone show invitation. Prices vary by quantity
ordered and services requested. Here is a sampling: 100/.21 each
($24 includes shipping and handling), 500/.12 each ($65), and
1000/.10 each ($107). Black-and-white printing is available for
an additional fee.

Post Script Press
2861 Mandela Parkway
Oakland, CA 94608
Phone (800) 511-2009 or (510) 444-3934
Fax (510) 444-2909
Call for current prices of four-color cards.

Presentation and Sale of Art on Paper

AutumnColor Digital Imaging
70 Webster Street
Worcester, MA 01603
Phone (800) 533-5050 or (508) 798-6612
Fax (508) 757-2216

Charrette ProGraphics
31 Olympia Avenue
Woburn, MA 01801-6897
Phone (800) 347-3729
Fax (800) 626-7889
E-mail custserv@charrette.com
Web www.charrette.com

Offering Reprochrome, Canon Laser Color, Fujix digital photos, Iris inkjet prints, SuperNova, Digimax, slides, and mounting services.

Color Q, Inc.
2710 Dryden Road
Dayton, Ohio 45439
Phone (800) 999-9818
Fax (937) 294-8896
Web www.colorqinc.com

Digital Plus
401 E. Illinois, Suite 310
Chicago, IL 60611
Phone (312) 464-0416
Fax (312) 464-9849
E-mail digital@digitalimagesplus.com

Electric Paintbrush
7 Oakhurst Road
Hopkinton, MA 01748
Phone (508) 435-7726

Impact Images
East of the Rockies:
2863 Highway 45-S
Jackson, TN 38301
Phone (800) 328-1847 or (901) 935-7700
Fax (901) 935-2720
West of the Rockies:
4919 Windplay Drive, Suite 7
El Dorado Hills, CA 95762
Phone (800) 233-2630 or (916) 933-4700
Fax (916) 933-4717
Transparent plastic picture covers, greeting cards, and hanging covers come in all sizes.

Today's Graphics
1341 N. Delaware Avenue, Suite 100
Philadelphia, PA 19125
Phone (215) 634-6200
Fax (215) 634-6619

Selling

Books

Davis, Harold. *Publishing Your Art as Cards, Posters &
Calendars*. New York: Consultant Press, 1993.

Davis, Sally Prince. *Creative Self-Promotion on a Limited
Budget*. Cincinnati, OH: North Light Books, 1992.

Davis, Sally Prince. *The Fine Artist's Guide to Showing and
Selling Your Work*. Cincinnati, OH: North Light Books, 1989.

Frischer, Patricia, and James Adams. *The Artist in the
Marketplace: Making Your Living in the Fine Arts*. New York:
M. Evans, 1980.
Good information on pricing your artwork.

Grant, Daniel. *The Business of Being an Artist*. New York:
Allworth Books, 2000.

Haller, Lynn. *Fresh Ideas in Promotion*. Cincinnati, OH: North
Light Books, 1994.

Hyman, Richard. *The Professional Artist's Manual*. New York:
Van Nostrand Reinhold, Co., 1980.
More help on pricing your artwork.

Leland, Caryn R. *Licensing Art & Design*. New York: Allworth
Books, 1995.

Magazines and Catalogs

Art Marketing Sourcebook for the Fine Artist. 3rd ed. Penn Valley, CA: ArtNetwork, 1998.
Lists over 300 art publishers.

Décor
330 N. Four Street
St. Louis, MO 63102
Phone (314) 421-5445
Magazine with information about print market.

North Light Book Club
Phone (800) 937-0963 or (513) 531-8250
Catalog comes out 14 times each year and is filled with subject-specific titles of interest to artists.

Shows and Juried Competitions

American Artist Magazine
1515 Broadway
New York, NY 10036
Phone (800) 745-8922
Web www.arttalk.com/AmericanArtist/american-artist.htm
Available at newsstands or your local library.

The Artist's Magazine
F&W Publications, Inc.
1507 Dana Avenue
Cincinnati, OH 45207
Phone (800) 283-0963 or (513) 531-2690
Fax (513) 531-1843
Web http://artistsmagazine.com/
Available at newsstands or your local library.

ArtWorld Hotline
ArtNetwork
P.O. Box 1360
Nevada City, CA 95959
Phone (530) 470-0862
Fax (530) 470-0256
E-mail info@artmarketing.com
Monthly newsletter.

Gadney, Alan. *How to Enter and Win Fine Arts and Sculpture Contests.* New York: Facts on File Publications, 1982.

Juried Art Exhibitions: Ethical Guidelines and Practical Applications

Chicago Artists Coalition
11 E. Hubbard, 7th Floor
Chicago, IL 60611
Phone (312) 670-2060
A $13 booklet to help in planning a show or competition.

Slides and Photographs

Photographs

Hart, Russell. *Photographing Your Artwork.* Buffalo, NY: Amherst Media, 2000.

Kodak hotline and catalog.
Phone (800) 242-2424
Web www.kodak.com

Photographing Your Artwork
Chicago Artists Coalition
11 Hubbard, 7th Floor
Chicago, IL 60610

Phone (312) 670-2060
Web www.caconline.org
Booklet for $5.95.

Wilhelm, Henry Gilmer, and Carol Brower. *The Permanence and Care of Color Photographs*. Grinnell, IA: Preservation Publishing Co., 1993.
Phone (800) 335-6647
Fax (515) 236-0800
$69.95 + $4.95 shipping. Yes, it costs a lot, but it's the best.

Duplicating Slides

Citizens Photo
709 SE 7th Street
Portland, OR 97214
Phone (503) 232-8501

David Allen Fine Art
68 Montague Street, Suite 8F
Brooklyn, NY 11201
Phone (718) 624-7504
.59 each, up to 200; .49 each after that.

Replichrome
89 Fifth Avenue #903
New York, NY 10003
Phone (212) 929-0409

World-in-Color
39 Caledonia Avenue
P.O. Box 170
Scottsville, NY 11546-0170
Phone (716) 889-1910
Free trial offer. Send two originals. Get two duplicates of each.

Slide Registries

American Craft Council
72 Spring Street
New York, NY 10012
Phone (212) 274-0630
Web www.craftcouncil.org
Slide registry and portfolio, photos, and biographical information on American craftspeople. (Send marketing package.)

ArtBank, Arts on the Line
Cambridge Arts Council
57 Inman Street
Cambridge, MA 02139
Phone (617) 349-4380
Web www.ci.cambridge.ma.us
Registry used by MBTA (public transit system) for selection of art used in stations and other public thoroughfares.

Directory of Artists Slide Registries (free catalog)
American Council for the Arts
One E. 53rd Street, 2nd Floor
New York, NY 10022
Phone (800) 321-4510, ext. 241
Web www.artsusa.org

General Services Administration (GSA)
Art and Architecture Program
7th & D Streets SW
Washington, DC 20407
Phone (202) 501-1812
Web www.gsa.gov

Slide Supplies

Labels

Iverson Photographics
31 Boss Avenue
Portsmouth, NH 03801
Phone (603) 433-8484

Light Impressions
205 S. Puente Street
Brea, CA 92821
Phone (800) 828-6216
Web www.lightimpressionsdirect.com

Sleeves

Clear File
1936 Premiere Road
Orlando, FL 32809
Phone (800) 423-0274
Web www.clearfile.com
Makes slide sleeves. Also newsletter information about why
high-density polyethylene is better than surface-treated
polypropylene, which is better than PVC. Also has information
on the effects of temperature and humidity on photographs.

Index